ISBN 0-942604-68-7
Library of Congress Catalog Card Number 98-067525

Book and Cover design by: Bernadette Evangelist
Cover Art: *Pensive*, 1996, Collection of Wes Porter
Frontispiece: *October Light*, 1997
Text by: Robert L. McGrath, Phillip Saietta, Paula Glick, Burton Silverman

Published by:
Madison Square Press
10 East 23rd Street
New York, NY 10010
Phone (212) 505-0950, Fax (212) 979-2207

Printed in Hong Kong

Essays by
Robert L. McGrath, Professor of Art History
Dartmouth College
and Phillip Saietta with Paula Glick

Memoir by
Burton Silverman

Foreword by
Louis Zona, Director
The Butler Institute of American Art

Preface by
Campbell Gray, Director
The Brigham Young Museum

This publication is made possible by a generous gift from

THE ROBERT LEHMAN FOUNDATION, INC. &
THE RICHARD FLORSHEIM ART FUND

Special thanks to
Steven Cherner, Paul Doll, Irving and Frances Phillips,
Wes Porter, Jeff and Cindy Sacks, Helen and Hank Seiden,
and Carol and Jerry Silverman

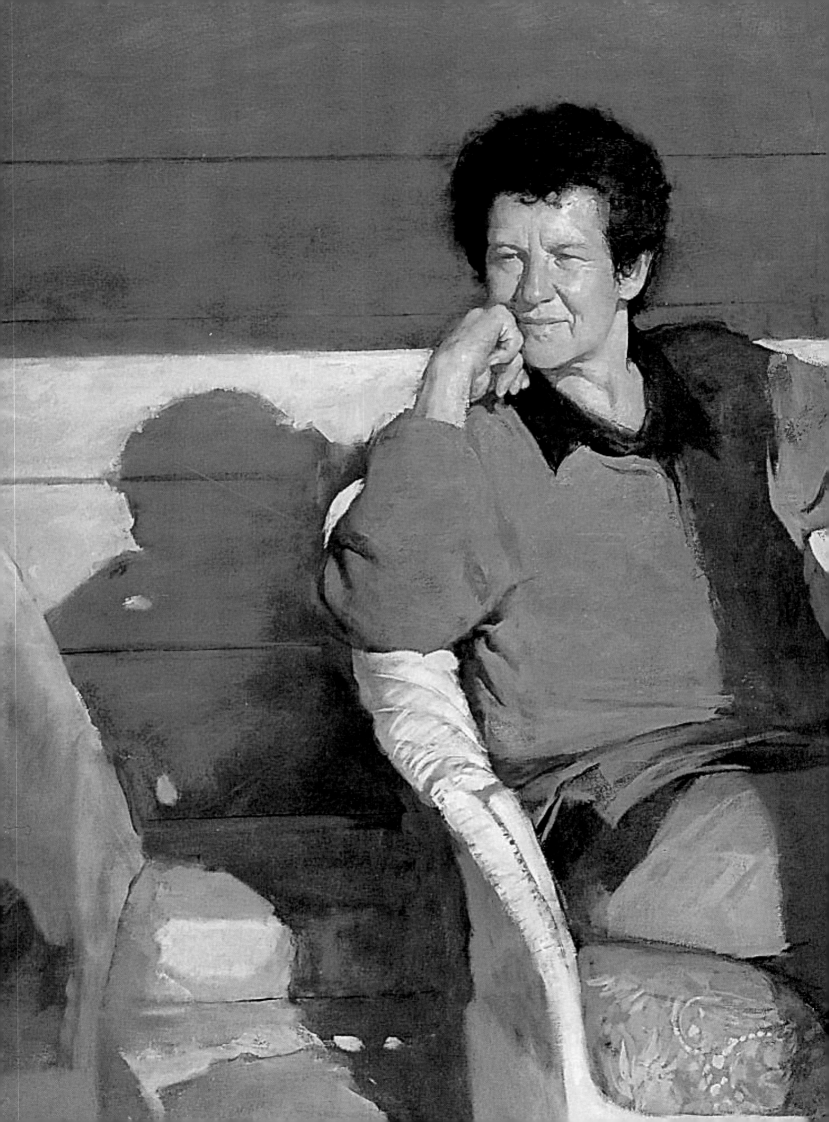

sight & insight

the art of BURTON SILVERMAN

THE BUTLER INSTITUTE OF AMERICAN ART
Published by Madison Square Press

Contents

Foreword

Burton Silverman is an artist who has propelled post war representational painting to a new plateau. His works excite us on many levels, foremost among them at the purely technical level distinguished by his remarkable handling of paint. To examine the surface of his canvas is to participate in a clinical demonstration of the topic of painterly painting. His virtuosity in the manipulation of the medium is a gift which few painters in the history of art have possessed. Silverman's understanding of our visual universe and the laws which guide it have served him well. This innate organizational sense is akin to the perfect pitch of a Sinatra. He rarely misses the ideal in the organization of visual elements which, for the artist who prizes a strong narrative, is a powerful combination.

Ultimately, Silverman's true genius lies not so much in his expertise in formal handling of paint or his splendid aesthetic choices. Rather, his brilliance as an artist lies in those intangibles which cannot be fully analyzed nor extolled. His greatest contribution rests in his ability to continually satisfy and stimulate his audience. He is an artist who enriches our vision and enhances our perception. He is an artist for everyman. In my judgement Burton Silverman is simply an exceptional artist who has forged a new synthesis in realist art. His work speaks to us not through aesthetic theory or the commonality of art historical reference. The appeal of his art is in the depiction of the commonplace in an extraordinary manner. He states it, and we are moved.

Our country's visual art history is filled with biographies of illustrators who ultimately became better known as painters and sculptors. Winslow Homer, Edward Hopper, George Luks, John Sloan and many others initially built reputations among the honored ranks of America's illustrators and are viewed today as cornerstones of our fine arts culture. Silverman has been one of this country's most celebrated contemporary illustrators for close to four decades. He joins this celebrated group by virtue of his own contributions to that culture. This exhibition, proudly presented by the Butler Institute of American Art, is an attempt to offer a far broader look at the accomplishments of this monumental talent.

A mutual friend of the artist and mine, the much loved collector of realist art, Phil Desind, once referred to Silverman's talent as the absolute best in the country. It is hard to argue with Phil's assessment. One need only walk through the exhibition to realize that in the work of Burton Silverman we have a true living master.

Louis A. Zona

Preface

Burt Silverman's work is focused intensely upon the hope that material, technique, surface, image and composition, will combine as strategies to enable the viewer to explore the character, context and value contained within the painting's subject. Indeed, Silverman's extensive experience is evident in the success of his paintings to achieve that objective. But carefully and consciously, in that success, Silverman presents a problem to the viewer—a problem that is at the core of art analysis. That problem is expressed in the Modernist tendency of some viewers to attempt to categorize in broad semantic sweeps, the difference between illustration and art, and in so doing, when it is determined that something is one of these, it is not the other.

Having spent many years directly engaged in work that responds to briefs given to him by editors and designers, and now more completely engaged in those visual and intellectual pursuits that are driven by his own motivations, his life itself exemplifies the dilemma. But to simply codify the relationship between image maker and editor as evidence of the "illustrator" at work, and the possibility of independently motivated procedures as evidence of the "artist" at work, is as problematic in theoretical terms as it is to determine that one painting is "illustration" and another, "art," simply by looking at them.

The context of display and the intentions of the artist semiotically received by a viewer who brings unique questions and interpretations to bear on the work, demands a more careful analysis of all forms and images. One is left to wonder about the efficacy of the terms, and whether their use closes down the possibility of receiving meaning that is far more significant to one's knowledge and morality, than the comfort of resolving a conflict in categories. Silverman's work presents the problem and demands a sensitive debate.

Dr. Campbell B. Gray, *July 1998*

Sight & Insight; The Radical Realism of Burton Silverman
by Robert L. McGrath

A slightly balding graybeard, informally clad in shorts, tank top and sandals, fixes us with a penetrating gaze while attempting to take our picture with a large (35 mm) hand-held camera. Any brief annoyance soon yields to relief as we come to realize that our initial response was mistaken; the focus of the camera's attention is not ourselves but the photographer himself. Rustic and bohemian, our paparazzo (who with a few adjustments for medium might have just stepped out of a Duane Hanson tableau) is not in our face; he is, so to speak, on our back. In mirrored reversal he is positioned within the fictive space of the image as a reflection and without it as an implied presence occupying our exact vantage. Inside the artwork he appears as a spectral witness, while as outsider, he is the animating agent of the image engaged in a process of transfiguring himself and others. As such we see ourselves seen and not seen, the subject and yet not the subject, of the camera's aggressive stare. Are we spectators or performers, the source or the object of surveillance? Has a picture been taken, and, if so, of whom and what? Could the horizontal field of vision that is experienced pictorially have been provided by a camera held vertically? Finally, is it possible that the subject is something not in the picture, something in back, rather than in front of the image? In short, what we see is not necessarily what we get.

There are, in addition, still further uncertainties and ambiguities embedded in this picture of a picture. Purportedly the result of a photograph, the work of art is palpably not the product of mechanical duplication. Employing a deliberately "painterly" facture (a process that is "foe-to-graphic" according to Landseer's well-known pun), the painter/photographer develops his composition in a visibly brushy manner. In polar opposition to the mechanized look of photography, and its sometimes ugly stepchild Photorealism, the painting is not meant to look like a pseudo or faux snapshot, and

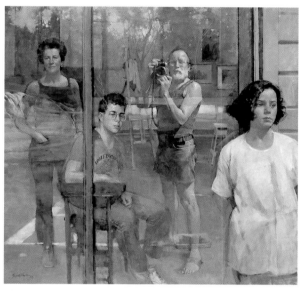

Figure 1. **Reflections**, 1987. (also Plate 11)

no apparent mechanical means has been employed to transfer the image to canvas. Diffuse and blurry rather than glossy and precisionist, the marks of the painter, the intercessions of brushwork, expressive modulations of figure, light and shadow (what the critic Arthur Danto has called "protective pigmentation") are everywhere invoked as a bulwark against the look of photography.[1] Though an absent signifier, it is clearly the painter's brush and not the camera's lens that has shaped the finished work of art.

There is, moreover, a final paradox embedded in this prolix canvas. In collapsing the distinction between artist and viewer, a phenomenon implicit in almost any image, but one seldom as aggressively staged as here, the artist affirms the primacy of his controlling gaze. We see not only what he sees but how he wants us to see as his reflected gaze mirrors our own act of witness. As such our eye is summoned in a directed response to perceptions determined by the maker of the artwork, the self-annointed arbiter of the image's claim to reality. Afforded by this displacement, a significantly diminished degree of agency in looking at the picture,

[1] Silverman's subversion of photography recalls the words of one of his spiritual mentors, Robert Henri: "A thing that is finished is dead...A finished technique without relation to life is a piece of mechanics, it is not a work of art." Robert Henri, "The New York Exhibition of Independent Artists," *Craftsman 18* (May 1910). Cited in H. Barbara Weinberg, Doreen Bolger, David Park Curry, *American Impressionism and Realism; The Painting of Modern Life*, 1885-1915 (New York, 1994).

our notional eye is coerced into conflation with the Cyclopean lens of the camera together with the binocular vision of the painter. In shifting our focus from eye to lens and back again our normative protocols for looking at art have been initially confounded, then manipulated and ultimately problematized.

In blatantly "exposing" the nature of his artistic practice, Burton Silverman here affords a glimpse into the complex nature of his pictorial vision.[2] Is it the objectivity of the camera's lens or the subjectivity of the artist's eye, the mechanical or the manual that determines the act of representation? Which is the more "truthful," we are enjoined by the image to ask, the camera's lens or the human eye, a photograph or a painting? (The old bromide that "photographs don't lie, they just don't tell the truth" applies here!) On another level, what is the nature of the dialectic between the objects portrayed and the artist's perceptions of them, the difference between marks on canvas and the Ding an sich? On the one hand, as an artist seeking a field of vision afforded by the photograph's exclusive way of transmitting information, he is forthrightly candid (no pun intended) about the role of the camera in assembling his pictorial constructions. Human perception in a postmodern world, he reminds us, is always already mediated by mechanical reproduction. On the other hand, the artist's refusal to look through the viewfinder, to instantiate, as it were, the intervention of the camera's lens between himself and his subject, would seem to assert the priority of individual perception and the primacy of painting over photography. The resultant image, a synthesis of what is seen and felt by the painter, together with appearances afforded uniquely by the camera, produces a subtle congerie of vision and memory. Inscribed upon the familiar family portrait is a mirror of his sensibili-

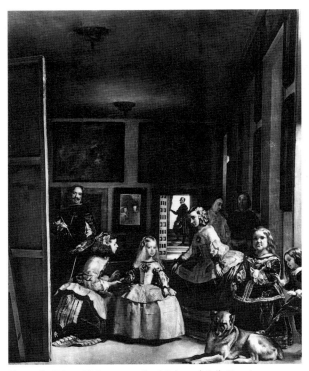

Figure 2. **Diego Velasquez**, *Las Meninas*, detail. Courtesy Alinari/Art Resource.

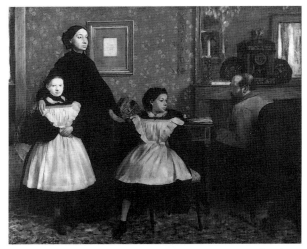

Figure 3. **Edgar Degas**, *The Bellelli Family*. Courtesy Alinari/Art Resource.

ty, the knowledge and procedures of a lifetime devoted to investigating the transparency of representation. As such this self-reflexive work affords the artist an occasion to discourse upon the traditional connection

[2] The only known work in which an American painter directly acknowledges the use of a camera in constructing his image is Don Eddy's *Harley Wheel Hub* (1970, Private Collection) in which we see a reflection in the chrome wheel hub of the artist aiming his camera. Cf. Louis K. Meisel, Photo-Realism (New York, 1980) Fig. 349. A painting in the Ganz Collection (ca. 1879) by Sanuel S. Carr, entitled *The Beach at Coney Island*, depicts a family at the seaside posing for a photographer. Staged as a family portrait, it is related to a similar canvas in the Smith College Museum of Art. See John Wilmerding et al., An American Perspective; Nineteenth-Century Art from the Collection of Jo Ann and Julian Ganz, Jr. (Washington D. C.,1981) p.121 & Fig. 48.

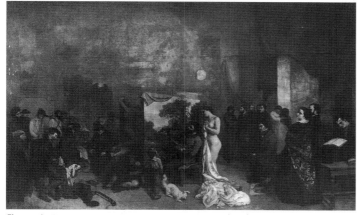

Figure 4. **Gustave Courbet**, *Studio of the Painter*, detail. Courtesy Alinari/Art Resource.

between people and paint and the authoritative role of photography in human self-definition.

Silverman's elaborated group portrait—a Conversation Piece without much direct communication—is also an exploration of human relationships, a narcissistic, as well as mildly parodic, form of homage to the artistic self, and a discourse with the history of European and American realism. Drawing upon such diverse pictorial sources as Velasquez's *Las Meninas* (1656, Madrid, Museo del Prado) (Fig. 2) and Degas' *Bellelli Family* (1858-62, Paris, Musee d'Orsay) (Fig. 3), the painter acknowledges many of the art historical influences operating upon his pictorial vision.[3] Refractions from art historical memory are imbricated with observations drawn from life, significantly inflecting the confrontation with actuality. *Reflections*, painted in 1987, is, in the fullest sense of the double entendre, a meditation upon the problematical nature of mimesis and the persistent role of history in shaping representation. Painted with Old-Master attention to dramatic pose, spatial logic and shifting appearances, *Reflections* deploys illusion against itself in order to attain heightened insight from the diverse processes of sight.

In the first instance there is the privileging of the artist's eye/I by virtue of his spectral presence along the central axis of the image (the precise axis is, perhaps ironically, occupied by an empty easel located within the space of the artist's studio). Enframed by paintings and the accessories of his craft, the artist is located visually in the realm of culture while standing physically in the world of nature. The first reference here is to the humanist tradition of the sovereign artist in his studio of which *Las Meninas* is the magisterial paradigm (albeit intriguingly subverted by the artist's physical relocation outside of the pictorial construct. Read death-of-the-artist theory?).[4] A secondary axis is provided at the left by a standing woman (the artist's wife/model—shades of Courbet's *The Studio of the Painter; A Real Allegory!* (1854-55, Paris, Musee d'Orsay) (Fig. 4)—and the mother of their two children) as she fixes us and her husband with a direct and confident gaze (her profession as psychologist is surely not irrelevant in this context!). Their son, also located within the studio, eyes his sister who, loosely patterned after the filiopietistic daughter in Degas' psycho-dramatic *Bellelli Family*, glances off-canvas. Physically nearest to the father/artist, she is, as a consequence of her averted gaze, the most psychically remote. The son, seated at what appears to be a swivel-top school desk, wears a T-shirt signifying a vague educational affiliation. Conversely, the daughter, clothed in the symbolic white of innocence, enacts the historic role of the artist's muse.[5] The Freudian dyad of mother/son (inside) and

[3] In his widely circulated publication *Breaking the Rules of Watercolor* (New York, 1983) Silverman argues strongly on behalf of the "validity of artistic borrowings" as both a didactic strategy and a way of connecting the past to the present. A well-known Photorealist work by Audrey Flack, entitled *Farb Family Portrait* (1969-70) (Rose Art Museum, Brandeis University, Mass.) in which a father, mother and two sons, one of whom aims a camera at the viewer, is closely allied in subject and spirit, if not style, to Silverman's painting. The classic study of the Conversation Piece, including numerous family portraits, is Mario Praz, *Conversation Pieces; A Survey of the Informal Group Portrait in Europe and America* (London, 1971).

[4] Another possible reading of the image pertains to the idea of the "outsider" in the world of modern art. According to this account the traditional realist painter in the second half of the 20th century must work without the critical and institutional support afforded to more "progressive" (i.e. non-mimetic) artists.

[5] This tradition, of which the artist might well have been unaware, is discussed by Viktoria Schmidt-Linsenhoff in an essay "Im Namen des Vaters; Die Allegorisierung der Kunstlertochter in der Bildnismalerei des 18. Jahrhunderts," in *Allegorien und Geschlechterdifferenz*, ed. S. Schade et al (Cologne, 1994) 73 ff. The writer wishes to thank his colleague, Angela Rosenthal, for drawing his attention to this little known iconography.

father/daughter (outside) is an added reification of the cohesive and fragmentary elements of the composition whose cleverly submerged armature is also reproduced by the competing trajectories of sight. Metaphoric of the centripetal and centrifugal forces working for and against the modern family, these divergent lines of vision suggest the fractures and unities within the larg-

Figure 5. *Reflections*, first state, 1986. Oil, 40 x 30 inches. (abandoned)

er group as well as the inherent instability of their multiple subjectivities. Congregated together in the name of the father, the artist, present at the creation, directs his family in a ritual documentation. Even as looks are received and reciprocally exchanged, we are implicated in the dynamic of these unfolding familial relationships. A simulated event and a psychological encounter, the image operates upon us voyeuristically in sundering the boundaries between private and public, near and remote, seeing and being seen.

Silverman's symbolic, as well as actual, deployment of the camera in lieu of the painter's brush, acknowledges that his art is not a direct, unmediated expression of what is seen. Rather, it signifies his long-standing practice of employing the camera to collect subjects from life for scrutiny in the recollected tranquility of the studio. Hovering on the unstable and

fluid boundary between mimesis and artifice, Silverman's paintings may be understood both to reflect external reality and to shape their own visual and ideational truths. Additionally, the image's narrative sub-text implies that even that most sacred of institutions, the nuclear family, can no longer be summarily convened to pose for the extended artistic interventions essential to such forms of traditional portraiture. Under the pressure of contemporary exigencies, perhaps only the serial imagery provided by the camera (i.e. life lived through a photo album) can be employed to stage the event. Enlarging the field of vision, the photographic lens serves not only to freeze the reflected landscape elements as well as to extend the wall of the studio, but also to reconvene the individual family members who may, or may not, have been present at this purportedly unified occasion. The painted canvas, empowered by the authority of the camera (perhaps a grudging acknowledgement of its vital role of providing figurative narratives in an age of pattern and decoration painting?) presents the familiar in the guise of tradition and vice versa. At base *Reflections* is very much about the attraction of opposites.

An oil study for *Reflections* (Fig. 5) indicates that the son was not part of the original convention. The daughter, moreover, appears several years younger, wears a striped rather than white top, and is considerably less of a presence. Significantly, the artist sketches directly from his models rather than registering the group photographically, his blank, strongly lighted sketchbook symbolizing the emergent act of creation. At the left an assemblage of the artist's parphanelia further amplifies the self-referential aspects of the work. A preparatory drawing (Fig. 6) reveals that the artist captured his own appearance by the traditional means of a mirrored reflection. In the finished canvas, however, the subordinate status of the wife is reconfigured to produce a leveling of heads denoting equality. Also revised is the proximity of the artist to the picture plane, thereby eliciting a stronger sense of compositional and family unity. Finally, the partial reflection of the rear end of a Volkswagen bug in the glass door

Figure 6. ***Study for Reflections***, 1985. Pencil, 12 x10 inches. From the artist's sketchbook.

the critically preferred style. Imperialist in their assertion of cultural primacy, the painters and critics of the New York School viewed traditional American realism as "mere literature," at best, a practice against which to react.[6] Then came, according to the canonical accounts, a sudden reversal. The unanticipated emergence of the "New Realism" during the 1960s under the combined rubrics of Pop, Photo-Realism and Superealism turned out, however, not to be a vindication of traditional realist practice. Vastly different in intent and affect from the studio or street realism that had preceded it, the "New Realism" was strongly indebted to abstraction for scale, planarity and artistic self-consciousness. At the same time it was resolutely anti-art in its preference for deadpan factuality, banality of narrative, and erasure of angst-ridden subjectivity. Whether reduplicating the imagery provided by advertising, billboards, journalism or, most importantly, photography, Superealism was not about people, places and things as filtered through an individual sensibility. Rather, these relentlessly mundane images were intended to denote the transmogrification of actuality by the intercession of those ubiquitous media that had come to constitue the new reality. By way of apparent contrast, the recent art of Burton Silverman attempts to elide the distinction between traditional realism, so-called "humanist realism" in which signification remains operative, and the "New Realism" which eschews metaphor, symbolism and narrative. Challenging the stylistic and ideational boundaries established by art historians and critics, Silverman strives to integrate the trajectory of American "realisms" into a continuum rather than privileging the episodic shifts of sensibility that produce exclusions. In this project of recuperative synthesis, he remains faith-

both dates and suburbanizes the sketch, a condition that is nostalgically pastoralized in the final version. A field for scopic reflection, Silverman's family portrait affords an occasion to memorialize the constituents of his vision together with the respective roles of photography, art history and individual perception in the art of painting.

From the later 19th century through the 1930s "Realism," in its various and several manifestations, was the dominant aesthetic in American painting. During the middle decades of the present century, as the history of art avers, abstraction replaced realism as

[6] In 1956, at the height of Abstract Expressionism's critical ascendancy, Silverman joined forces with a group of fellow realists to mount an exhibition at The National Arts Club in New York City. Entitled "A Realist View," it was organized as a defense of tradition. Its polemical manifesto attacked Abstract Expressionism as "a variation on the Rorschach Test." Slightly earlier a second group with a similar agenda and led by the doyen of American "street realism," Edward Hopper, formed a coalition to publish an art journal with the title *Reality; A Journal of Artists' Opinion*. Neither effort met with much success at the time and it was only with the advent of the "New Realism" in the early 1960s that the problematic of figuration versus abstraction began to claim renewed interest. For an account of these events, which, arguably, produced in Silverman a sense of being an "outsider" see: Greta Berman and Jeffrey Wechsler, *Realism and Realities; The Other Side of American Painting* 1940-1960 (Exhibition Catalogue, Rutgers University Art Gallery) 1981.

ful to the mandate of humanism, embracing the past in order to revise the present under the perceived conditions of reality.

The collusion of direct and mediated perception with history in the development of Silverman's imaginary is nowhere more evident than in a recent series of

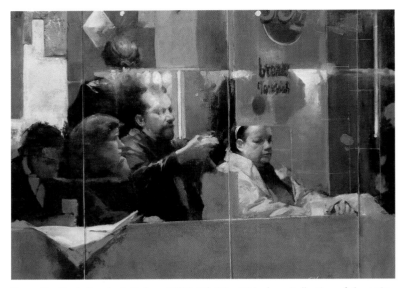
Figure 7a. Study for **Arch Deluxe**,1997. Oil, 24 x 30 inches. Collection of the artist.

paintings based on the contemporary urban scene. Loosely dependent upon the broader modernist tradition of "street realism," these images seek to interrogate, in the manner of socially concerned art of the 19th and 20th centuries, the human condition in a techno-urbanized world of consumption and display. At the same time, they attend to the "new realities" defined by the avatars of media culture. The painting entitled *Arch Deluxe* (1997) (Fig. 7), though based on a synthesis of photography and direct observation, consciously or otherwise, invokes one of American painting's most celebrated icons of urban anomie, Edward Hopper's *Nighthawks* of 1942 (Chicago Art Institute). Positioning his paintings within the context of Western realism, Silverman respectfully acknowledges his sources and their iconographic revision in the light of contemporary concerns and sensibilities. The artist's

location of the viewer close to the picture plane, however, represents a conspicuous departure from Hopper's nocturnal masterpiece in which the spectator is situated across the dark street from the all-night diner. By contrast, Silverman creates a space that requires our immediate involvement as passers-by on the sidewalk, an involvement that is, however, frustrated by the imposition of a commercial plate-glass window between ourselves and the protagonists of the painting.

Historically, American artists have expressed solitude and isolation through the diminished scale of staffage in relation to the surround or through distant location of figures in space. In conformity with more recent practices, derived from photography and Photo-Realism, Silverman positions us at street level and near to the plate-glass window of a fast food restaurant in order to be able more closely to scrutinize the diners (the pose of the central figure is roughly a reprise of that of the woman in a red dress in Hopper's scene, a time honored signifier for melancholic reflection). Mirroring Henry James's claim that cafe life in America, unlike the street theater of France, is a curbside experience of near and remote (Simmel's "city of strangers"), the painter draws physically close in order to emphasize the psychic distance between people in metropolitan settings.[7] In sharp contrast with the family portrait, there is no exchange of gazes among these

Figure 7. **Arch Deluxe**, 1997. (also Plate 66)

[7] Henry James, Parisian Sketches, Letters to the *New York Tribune* (London, 1958). 39ff. For the classical sociological account of urban estrangement see Georg Simmel, *On Individuality and Social Form* (New York, 1971).

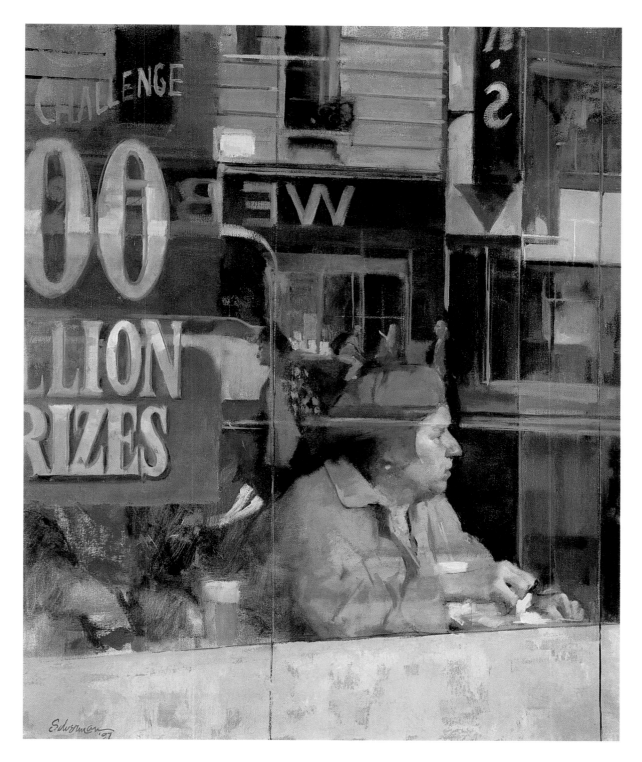

Figure 8. ***100 Million Prizes***, 1997. 30 x 24 inches. Private collection. (also Fig. 26)

isolated individuals. Deployed as a frieze in nearly identical poses, these inner-directed figures can be understood to express the automated regimentation of urban life as well as the putative quality of American fast-food consumption. Styrofoam cups, lurid signage and garish neon lighting produce an atmosphere of sterility and artificiality. Distinctions in class and gender are also subtly evoked, the well-dressed (and pre-

sumably well-read) figure at the left contrasted with the men on his right. Males are foregrounded while women are located more ambiguously in deeper space. The democratic freedom to mingle in urban spaces is evocatively contrasted with the array of social conventions which lead to separation. Devoid of all traces of conviviality, this arid streetscape contains no vestiges of the putative gaiety of the Parisian cafe.

The plate-glass window, a principal formal and

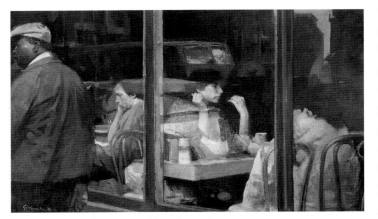

Figure 9. **Bagel Nosh**, 1986. (also Plate 65)

symbolic device in the work, constitutes a second plane within the picture upon which the artist can inscribe signs and letters. This surface, when read opaquely, allows for the play of quasi-Cubist abstraction; when viewed as transparency, it carries a modernist linear grid which further serves to regularize the composition.

Appearing, at first, to work against the coherence of the image, these abstractions, which together with the reflections playing across the glass, establish a kind of shrill dissonance that ultimately fortifies the deeper meanings of the work. Signs and letters (the ironic connection between "fast" and "meals" providing a case in point) express the intended connections between style and content, the organic linkages that constitute the fundamental probity of Silverman's vision. An emblem of contemporary alienation, of public spaces and private thoughts, of physical proximity and psychological

separation, *Arch Deluxe* speaks to the isolation of the self in the spaces of post-modernity. In this astringent world the "covetous and erotic" gaze of modernity's flaneur yields to that of figures engaged in varying degrees of self-absorption.[8] The ephemeral aim of our disinterested glance, these urban specimens under glass become, so to speak, the objectified staffage of the society of the spectacle.[9]

The painting *100 Million Prizes* (1997) (Fig. 8) further envisions the theme of human isolation in the midst of urban abundance and visual hyperstimulation. Enframed by an avalanche of signs, applied to and reflected in the plate-glass, the solitary figure of a woman gazes off-canvas as if to suggest her relative insulation from their insistent claims. The presence of a prominently inscribed double zero, surmounted by the ambiguously located word "challenge," enjoins the viewer to reflect upon the nullity of the promises of lotteries, game contests and other forms of false promotion. Despite her apparent indifference to the omnipresent icons of commercial hype, the figure is nonetheless virtually subsumed into a mosaic of signs. As over and against the iconographic precedent of Hopper, with his muted references to contemporaneous advertising, Silverman's inside-out world of meretricious accretion, constructs an environment of near total commodification in which the ability to resist the blandishments of consumption hangs precariously in the balance.

Bagel Nosh of 1986 (Fig. 9), one of the few instances when the artist includes a figure on the sidewalk, affords an occasion to discourse on the racial divide in America. The image of the black man, separated from the occupants of the cafe by the plate-glass window, resonates with a long established tradition of representing the cleavage between black and white by the use of enclosed interior spaces. Fortifying both the theme and the composition is the presence of strong

[8] Griselda Pollock, *Vision and Difference; Femininity, Feminism and Histories of Art* (London, 1988)

[9] Guy DeBord, The Society of the Spectacle, "the world of consumption is the world of mutual 'spectacularization' of everyone, the world of everyone's separation, estrangement and non-participation."

vertical dividers between the plate-glass windows. A distant echo of similar dividers found in the cafe scenes of Manet and Degas (where, characteristically, they function to produce intimacy), they are here used to heighten the level of estrangement among the protagonists. American paintings, ranging from William Sidney Mount's *Power of Music* (1847, Cleveland Museum of Art) to Reginald Marsh's 1930s scenes of Bowery movie palaces, invoke the theme of racial segregation through a related spatial semiotics of inclusion and exclusion.

What constitutes the appeal of this persistent American trope of urban isolation and lack of conviviality? Is it, as some critics have claimed, that in constructing a public spectacle of alienation, artists make us comfortable with our own sociability? Or do we recognize in this psychological condition something of our own experience of the divide between our public and private selves, and the moral dilemmas of metropolitan life? Perhaps the recurrence of the theme of estrangement in our national culture represents a reflexive response to the virulent anti-urbanism embedded in the broader myth of American Exceptionalism (there are no strangers in Nature's Nation!). Arguably, these images may well embody at some submerged level a desire to reintegrate the family of man, to recover a semblance of urban civility. To describe, in this sense, is to master and, possibly defeat, the forces of estrangement.

A second, related question concerns the marketability of this alienating and alienated imagery. How is it that, at least since the second decade of the 20th century, urban realists, led by the likes of Edward Hopper and Reginald Marsh, have been able (presumably with the support of the broader public) to focus upon the darker side of American experience? How can a society, historically condemned and/or celebrated for its cultural "euphemism, optimism, nationalism and nostalgia," come to view the human condition in such an unfavorable light? Is it that the philosophical morbidity that underlies this iconography serves to delineate our collective guilt, the sense of the nation's

failure to create livable urban spaces? Such imagery, according to this account, can only be construed as a surrogate, a grim reminder of our inability to act in the face of America's professed democratic idealism.

Another recent work, entitled *Pier 72, The Information Age* (1995), revises one of the seminal masterpieces of urban estrangement, Edgar Degas' *Absinthe* of 1876 (Paris, Musee d'Orsay). This artfully constructed exploration of the social geography of the city is one of Silverman's most fully realized works.

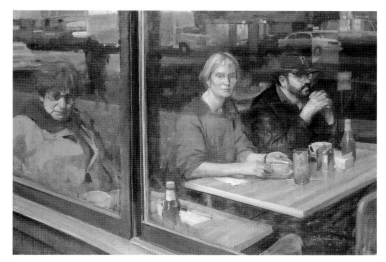

Figure 10. *Pier 72; the Information Age*, 1995. (also Plate 63)

The almost formulaic American belief in the inability of individuals in urban space to connect is instantiated by the divergent axes of vision as well as the inexpressive countenances of the figures. As over and against Degas' devastating revelation of urban dissolution, however, Silverman invests his principal figure, a blond woman in a green blouse, with an aura of memorial dignity. Unaware of the attention of the passer-by, she appears to rise above the general condition of despondency in order to embody some higher quality of human potential. Unlike the older woman at the left, who slumps awkwardly against a brick wall, or the adjacent bearded man, lost in reflection, she turns her head subtly in the direction of the viewer, asserting some indefinable degree of agency, while serving as the visual focus to anchor the triad of human heads. Her demeanor, in contrast with that of the derelict woman

in Degas' "study of human degradation," is one of emergent self-awareness; coffee rather than absinthe, ketchup bottle in lieu of empty carafe, serve as mundane signifiers for this seemingly unexceptional moment. Bounded by the crossed axes of the floating table tops and the truncated frame of the plate-glass window, the figures are both confined and stabilized by the network of diagonals, the artist's signature scaffolding of lines and planes, set against surfaces and spaces. In striking a keen balance between firm, academic modeling and a more summary, expressive form of brushwork, Silverman employs paint both to describe form and to maintain its essential identity as pigment. Recognizable shapes conspire with densely scumbled surfaces of paint to produce a work of both ideational

and formalist complexity.

This forceful composition, deliberately muted in color and understated in narrative, operates on several levels of meaning. The diagonally receding plate-glass window functions as a principal element of the composition. A metaphor for sight, the transparent window also denotes freedom and containment, accessibility and inaccessibility, closure and disclosure. One of the few inherited symbols from the past that still resonates, the vitrine/window continues to serve as a mirror of the artistic imagination. While the window in Christian art, according to the established account, was understood as the painter's eye, providing access to the divine and linking the visible to the mind (Leonardo's *finestra dell'anim*), for the modern world it has generally served

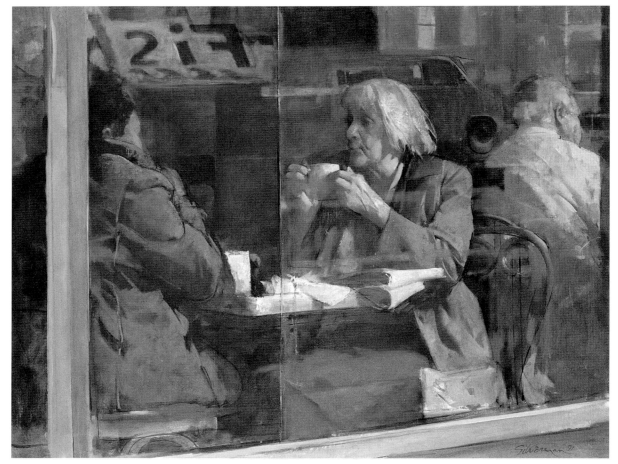

Figure 11. **Lunch Date**, 1992. (also Fig. 25 and Plate 62)

to symbolize human vanity as well as the paradoxical nature of art.[10] Employed as symbol, it signifies disunity and separation, as a formal device, it serves as a picture plane for aesthetic oscillations between figuration and abstraction.

In Silverman's more recent work, the glass pane functions not only to increase the sense of separation through the imposition of a transparent barrier between the curbside viewer and the subject (i.e. the deflection of the outsider's eye by reflections from the glass) but as a pictorial surface to be developed aesthetically. Thus the social problematic of our freedom to view versus suspension of access is elicited while the respective formal claims of abstraction and representation are simultaneously resolved. Silverman's almost alchemical capacity to achieve a kind of alienated sympathy with the living energy of the subject is further enhanced by the formal structure of the work, the use of a transverse, rather than frontal, perspective serving to actualize the viewer's relationship to the scene. Denoting, as in the past, the fleeting and momentary, the oblique view serves to render the scene immediate and accessible. But in shifting the cone of vision emanating from the artist/spectator's eye from the vortex (the unified Renaissance window) to the vertex (the normative vantage of American street realism) a separation of realms is achieved. Inside stasis rules, outside all is flux.

The achingly moving *Lunch Date* (Fig. 11) brings this sequence of images to a semblance of closure. An elderly white-haired woman, her back to one customer, gazes across a small table towards a partially revealed companion. This striking figure, the visual center of the compostion, lifts her eyes and coffee cup from a folded newspaper to acknowledge the presence of a fellow human. Unlike the *jolie filles* of the Paris Impressionists, or the attractive "bachelor girls" of New York's street realists, this excruciatingly plain senior citizen arouses in the spectator none of the admiring or covetous gaze associated with these pictorial traditions. Rather, Silverman invokes an older order of humanism in which intimations of mortality and longed-for social harmony are the dominant concerns. In this evocative revision of the "heroism of modern life," into a simple act of communion, Silverman has produced one of his most memorable and redemptive paintings, a mirror of life as lived and as hoped for.

The reflective plate-glass window, bifrontal to the viewer as well as the subjects of Silverman's specular art, serves, in the final analysis, to call into question the divide between reality and illusion, fact and fantasy, genuine and fake images of humanity. In responding to the historical realist mandate to move beyond self-reflexive formalism in order to reestablish a meaningful unity of style and content, to investigate the nature of art as it applies to vital social concerns, Burton Silverman has produced, in the context of the present historical moment, a truly radical realism. Embodying an embattled yet abiding humanism, his images defend the necessity of art. In this age of massive retreat from the public life of the city, his art reminds us of the social and political imperative to strive for integration in the face of dissolution, to find solutions to those forces of "separation, estrangement and non participation" which beset us at every turn. If sight is to remain the noblest of the senses, then it must provide the necessary insight to reconstitute a sense of human possibility from the abject spectacle of Silverman's fallen metropolis.

[10] For the definitive study of this theme see Carla Gottlieb, The Window in Art; *From the Window of God to the Vanity of Man* (New York, 1981).

On Women; The Nude Revisited
by Phillip Saietta with Paula Glick

From Madonnas and martyrs to courtesans and queens, women have been the subject of great art for the last five centuries. This is hardly surprising, since men have been the artists. Burton Silverman's contribution to this genre has been unique. His paintings of women in a wide variety of circumstances, young or old, clothed or nude, have always depicted his subjects with a single identifiable characteristic—their essential human dignity. The women in his art are painted with a directness and honesty reminiscent of the tradition of Eakins and Wyeth. His art has indirectly touched on a variety of social issues, because he has seen women as the focus for the tumultuous changes in the social climate over the last thirty years. During the 1960s, the status of women was radically altered, spurred in part by the anti-war movement, the openness toward sex, and the nascent feminist movement. Silverman recorded these changes in his subjects almost intuitively. These changes also coincided with his growing personal vision about the irrelevance of traditional nude painting, which he also found to be a worn and somewhat exploitative one. He was led to search elsewhere for a way to present the nude in a fresh and challenging manner. His understanding of women was also altered to a large extent by his becoming a parent and, for a while, assuming much of the nurturing role traditionally associated with women. An early painting called *Father and Son* (See Odyssey, page 40) was both an attempt to celebrate his new-found status as a "playground father" and a statement to balance the almost universal focus on motherhood in art history, as represented most recently, for example, by the work of Mary Cassatt.

Silverman's images range from attractive young women whose personas are not fully formed to sensitive readings of older women, who have largely been left out of the iconography of older art. His nudes, derived initially from the art-school genre, have become paintings of topless dancers or strippers who seemed outside the pale of respectable art. In a postwar environment that has featured incredibly provocative art centered on sex and nudity, his challenge was to

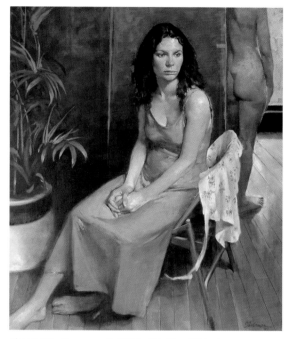

Figure 12. ***Crossroad***, 1997. Oil, 31 x 20 inches. Collection of Mrs. Taeko Yonetani.

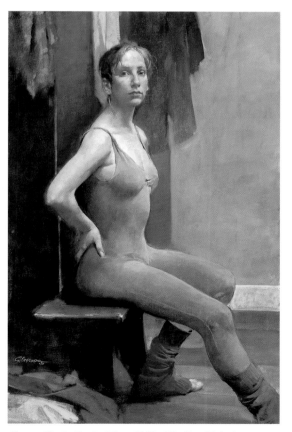

Figure 13. ***Ballet in Blue***, 1996. Oil, 42 x 38 inches. Collection of Mr. Jim Webb.

convert the subject matter into some kind of insight about our fears and preoccupations with sex.

In the 1960s, as the career options for women began to change, the artist, perhaps without fully understanding how these changes affected the lives of the young women who were to become his models, was gifted enough to find in their faces and in their gestures signs of these conflicts. His paintings evinced a sensitivity that has become his signature vision.

Silverman's models for his studio classes came

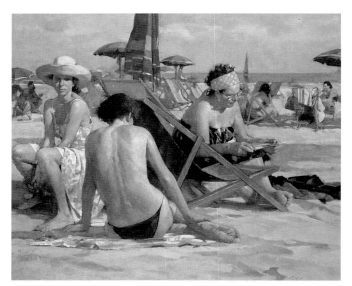

Figure 14. *Three Beach Figures*, 1990. (also Plate 49)

from a different, less professional group of people than was available in his student days. This new breed consisted of younger women—often in their early twenties—who sought work to support other careers. They were often dance students or young actors and were portrayed as lost in their thoughts, oblivious to the viewer (Fig. 13). More often than not they were seated, as in the painting *Crossroad* (Fig. 12), with shoulders rounded and their clasped hands revealing something of their underlying anxiety and yearning. This painting in particular, with a torso of a nude enigmatically standing in the background, suggests something of the dichotomous choices facing the young. In other of his works he found his subjects to be defensively armored against the perils of maturation—of making choices. A childlike demeanor and a girlish look were part of this

defense. He used this posture in a particularly telling fashion in the figure with a sun hat in the painting *Beach Figures* (see Fig. 14 and Plate 49). This painting, among other things, evolved into a contemporary remake of a traditional Old Master theme—the Three Ages of Man—now seen as Wo-man. Silverman deliberately emphasized the immaturity of the young woman by making her limbs and chest less developed in contrast to the figure of the more sexually aggressive, topless companion and the mature "mother" image of the older, seated woman. The younger woman/girl has her head covered and her body curled in on itself, which serves to identify her body as defensively closed off and sexually unavailable. Her ripe companion fully accepts her sexuality with unbound hair and unfettered body. Silverman's use of light and shadow reinforces the contrast among the three women, and together they form a triad of the three stages of life. While they are seen together, their separateness is subtly implied by the internalized, self-involved nature of each pose. This underlines the poignancy of the scene and, indeed, the idea of aging.

Silverman also studied the young women who, in coming to terms with their sexuality, seem to choose a more complex and difficult path. A major painting, *Two Women* (Fig. 15), is a dramatic exploration of the issues of gender. Two young women confront the viewer; the standing figure, with her orange shirt boldly open to her waist, looks unflinchingly and yet guardedly at us. Her stance is masculine, with legs apart and hands in pockets. She is attractive, and her sensuality is implied by her open shirt and the contour of her partly revealed breast. The casual directness of her pose underscores the look of sexual availability. But of what kind? The other young woman is seated with a man's hat framing her head, her body concealed within an oversized coat (a man's?), and her head turned away from the viewer. She seems grim and anxious and her tension is revealed by her tightly clasped hands, with the thumbs pressed against one another. The two young women are backed against a wall on which hang two pictures of women: one an expectant

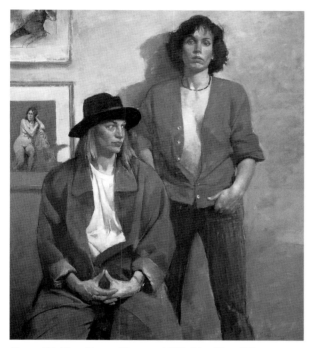

Figure 15. ***Two Young Women***, 1987. (also Plate 37)

chologist and thoughtful, maturing woman. His paintings of her reveal the warmth and depth of his feeling for her without sacrificing the unflinching honesty of vision that marks his paintings. Her image in a doorway (Fig. 17) may be one of his most successful portraits. Although she is dressed and posed informally, the painting is nonetheless reminiscent of the dynamic portrait of Isabella Stewart Gardner in Venice by Anders Zorn. Lit from the side and below, captured by time and light, Claire seems ageless, an icon of American womanhood at the end of the 20th century. In this painting Silverman captures the energy and

mother, the other a nude. These stand for the twin socializing forces for girls growing to maturity, and are a clear visualization of the classic whore/Madonna dichotomy. The ambiguity of their relationship becomes the driving force of the content of this painting, and the viewer is left with a feeling of discomfort for the dismaying loss of convenient stereotypes by which we view gender and sex.

A smaller painting of the same two women (Fig. 16) seems to offer some resolution to the conflicted emotions embodied in the earlier work. Although the poses remain the same, the expressions on their faces seem more relaxed, more introspective. The women are seen from the side, allowing the environment to play a larger role in the content. The room extends to a distant door, with light streaming in and reflecting off the pictures on the wall behind them. These faceted reflections suggest other options for these women, and the choices seem framed in light-filled promise.

Silverman's paintings of his wife, Claire, provide us with some possible insight into their marriage. A frequent model, she is painted in a variety of situations that chronicle her life as a mother, craftsperson, psy-

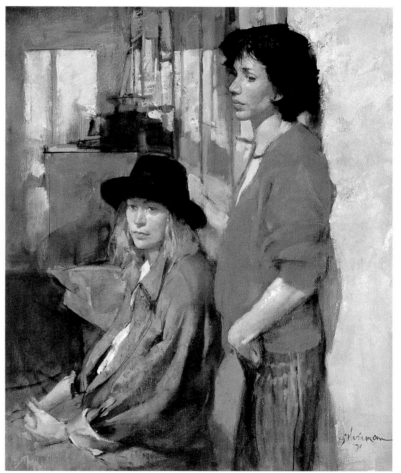

Figure 16. ***Two Young Women II***, 1990. 24 x 18 inches. Private collection.

intelligence in Claire that is also emblematic of these women. A clinical psychologist by training, her understanding and compassion often seem to permeate his paintings. Claire appears to be the incarnation of the

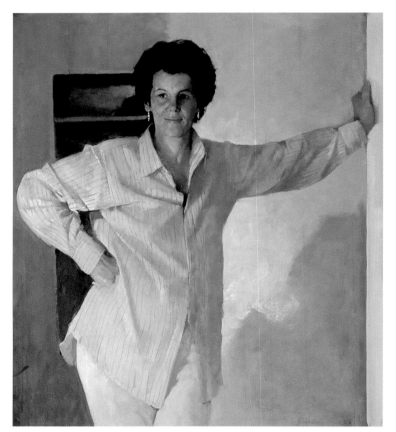

Figure 17. ***Claire***, 1988. Oil on linen, 36 x 32 inches. Collection of the artist.

"nude" as proscribed by Sir Kenneth Clark in his seminal study of the nude in Western art.[2] It also allied him to Ingres's voluptuous and erotic painting of the *Turkish Bath* (The Louvre, Paris). In Silverman's early work, he depicted these performers with heavily-made-up, mask-like faces, and focused much of his attention on the movement of their bodies and the provocative nature of the dance. The following excerpt from a publication by the Portsmouth Museums was written by a female curator and is particularly pertinent: "In the painting of *The Stripper* Silverman takes us into the burlesque houses where human dignity is sold for a very low price. The stripper wears contempt in equal measure for the job she is doing and the implied men that are watching. Her body is 'stripped' of its natural beauty with the vulgar suggestive pose.[3]

In seeking out these frankly sexual subjects in topless bars and the old burlesque houses, Silverman sought to deal with the complex issues of the disreputable yet arousing nature of public nudity, and how to aestheticize it. He sought to do this by making portraits of the performers, thereby eliciting our interest on a purely human level (Fig. 18). The burlesque topless dancer had become an individual and not a stereotype. She became a working woman confident in body and persona, who exploited the voyeur's desire for visual excitement while manipulating the process for her own gain. She was the consummate professional who now existed as all other "professionals"—actors, lawyers, accountants—by providing a service.[4] But, though she is a "professional,[5] she is also quite vulnerable to feelings of shame or regret; flashes of despair are captured in the painting *Party Girl* (Fig. 18). In other paintings, a

biblical woman of valor[1]—and she is his life's companion and guide.

Many of Silverman's nudes are descendants of the burlesque paintings of Edward Hopper and Reginald Marsh. Nevertheless, they are significantly different in that the artist eliminated much of the theater environment and chose a close-up focus on the nude bodies of the performers. This then became his conversion of the "classic" nude to an event in the culture at large, without the mythic trappings that prevailed in much older art. It bordered on the "naked" as opposed to the

[1] Proverbs 31:10-31

[2] *The Nude: A Study in Ideal Form*, from the Mellon Lectures at the National Gallery, June 1953, Sir Kenneth Clark.

[3] Commentary in the Museum's *Newsletter*, Nov.-Dec. 1982, of the study for the pastel *Stripper*, which the Museum acquired for its permanent collection.

[4] In the "business," as stripping is called by its participants, the word "pro" has dual connotation. It is often slang for a prostitute as well as someone who meets the criteria of a professional performer.

[5] See the article by Paul Theroux in *The New Yorker*, June 15, 1998 on *The Nurse*, a dominatrix queen of the S&M netherworld.

combination of defensive boldness and sharp intelligence holds the viewer at a distance and tells him he may look but not touch. The contract between the performer and the viewer/voyeur is one framed by control, and both are caught in the web of its destructiveness. But it is nevertheless this insight into her person-

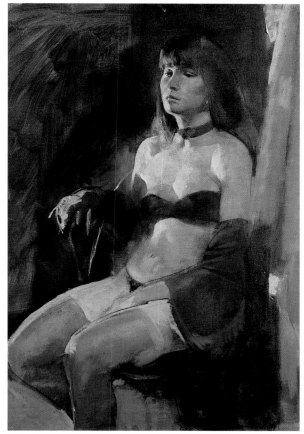

Figure 18. ***Party Girl***, (series) 1990. Oil on linen, 30 x 24 inches. Collection of the artist.

ality—her defiance and vulnerability—that makes this woman all the more real to the artist and all the more tantalizing to the viewer. It is interesting to use the painting *Ballet in Blue* (Fig. 14) for comparison, to understand how the look in these faces is markedly different and how that changes the content of the art as well.

Figure 19. ***The Stripper***, 1986. Pastel, 24 x 12 inches. Collection of the artist.

These paintings play a similar role to that of Manet's painting *Olympia* (The Louvre, Paris), which shocked 19th century Paris. The picture was a historic break with traditional paintings of the nude, and the Paris art world was scandalized by the portrayal of an apparent prostitute in a pose that echoed one of Titian's recumbent goddesses. It was a slap in the face of Art and decency. Without the trappings of Myth (Galatea and Pygmalion for one), his Olympia was momentarily stripped of legitimacy.[6] Silverman has taken a subject—the strippers—similarly unprotected

[6] In 1890 the painting was hung in the Orangerie of the Luxembourg palace where new acquisitions for the Louvre were first placed. After John Singer Sargeant warned of its possible acquisition by an American collector, a public subscription was organized to buy the work, which was finally listed definitively in the collection of the Louvre in early 1960.

by aesthetic conventions, and proposed it as a valid and important area of painterly investigation. In the course of doing so, he has put a human face on an activity that tends to offend conventional proprieties and challenged a society that already feels its values—its morality—in jeopardy. But unlike the more combative and confrontational uses of sex in art that have flourished in the last few decades, in Silverman's paintings there is an abiding feeling of compassion for the subject. In addition, these paintings are beautifully crafted, which further enhances the content, and, by the same token, validates their acceptance as art.

Silverman sought other arenas in which to paint the nude and thus rethink the question of the nude in painting. *T-Junction, Rte 52* (Fig. 20) is an interesting and challenging departure from studio or interior nudes found in recent realist art. Unlike the nudes of Hopper and John Sloan, which are seen safely within a room,

Silverman's nude standing by the side of a deserted country road reminds us again of the essential loneliness and isolation we have all experienced at some time or another. Silverman's painting here also reflects the artist's involvement with the specific, portrait-like characterization of the nude. Her stance is a curious reminder of Botticelli's *Birth of Venus* (The Uffizi, Florence), but this contemporary sister of hers does not hide her sexuality. Her body, with the exposed pubic hair, is bathed in the harsh 20th century light. Silverman echoes the fecundity of her body in the verdant greenery of the landscape and contrasts her soft, yielding flesh with the angular hardness of the adjacent rock. This contrast is heightened by the fact that the same raking, pinkish light falls on both the rocks and the flesh. This has a dual impact of linking the durability and the hardness of the rock to the strength of character depicted in the figure and, at the same

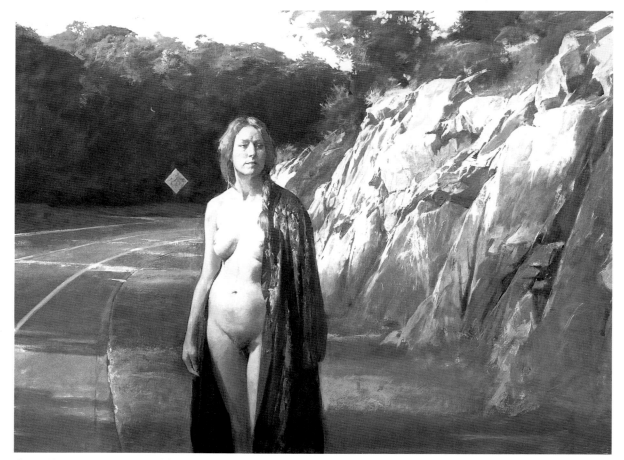

Figure 20. *T-Junction, Rte 52*. (also Plate 59)

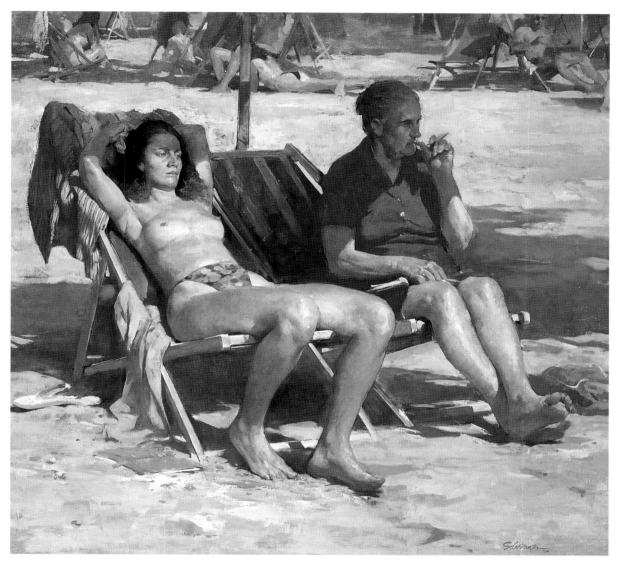

Figure 21. *Two Women*, 1995. (also Plate 55)

time, adumbrates her fleshly vulnerability.

This painting is disturbing. A young woman, nude, on an isolated country road, conjures up nightmare visions of rape and abduction—the violence that is usually associated with urban settings. But it is also a threat to this "Arcadia." The title of the work, *T-Junction, Rte 52*, implies that she is at or near a crossroads—a place where unknown elements co-join. The half-draped yet exposed body suggests an equivocal stance towards sexuality. And despite her confident look, she is vulnerable to those very unknown forces. Is this an allegory of the contemporary American experience? Is this about a modern American sensibility that

is fearful of sexual freedom, even while it venerates Mother Nature?

Silverman has used the nude to suggest other allegories, some of which have a reference to art history. The painting *Two Women*, 1944 (Fig. 21), is not only a direct observation of two women two generations apart, but it also conjures the visions of Goya's etchings. These often-depicted older women, called duennas, were caretakers of the virginity of their young, royal charges. Here the topless young woman reveals herself without apparent reticence, but with a look of apprehension on her face. She is side-by-side with her grandmother, who wears a typical dress worn by

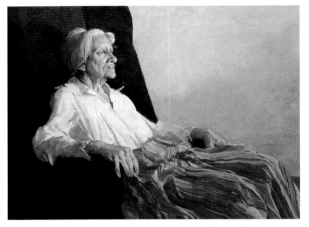

Figure 22. *The 18th of May; My Mother*,1987. Oil on linen, 26 x 24 inches. Collection of the artist.

women her age, but makes a gesture—smoking a cigarette—that links her to a kind of freedom usually not associated with her generation. Both are lost in reverie. The paired figures are a contrast of youth and age, but are tied to some common understanding—the fact that the old woman was once young and the young one will become old. This relates to the reminders of death that appeared in Renaissance paintings. A large inscription above the figures in the Masaccio fresco, *The Holy Trinity With the Virgin and St. John*, 1425 (Florence, Santa Maria Novella), has the following message:

> *I was once what you are now, and you*
> *will be what I am now* [7]

However, Silverman has more to say. Despite the age of the older woman, she does not seem defeated or resigned. As noted above, her stance is not constrained by age; she appears determined and independent. This surely reflects the artist's changing view of what it might mean to be "old." His earlier view of aging women, as typified by the portrait of his mother (Fig. 22), also documents the poignant acceptance of death. The painting is a powerful rendering of a person caught somewhere between life and death. There is an indescribable quality in this painting—something about the sudden consciousness of mortality—that almost feels as if, somehow, the artist has entered that

consciousness through his art. The spiritual quality in this work has profoundly affected many who see this painting.

As Silverman entered his seventh decade, his painting reflected a growing sensitivity to these issues. His work began to respond increasingly to these older women, both as interesting models in themselves and as prophetic icons of his own future. Understanding the new vitality of the gray panther generation, he found a place for them in his paintings. The mature woman in the foreground of the painting *Christmas '88* (Fig. 23), completed in his sixtieth year, stands before a shop window filled with elegantly dressed fashion mannequins. Among the clouded reflections in the plate glass is the image of the head and hands of a

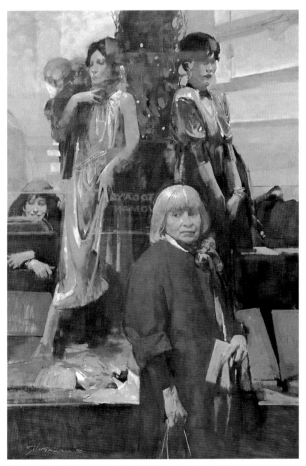

Figure 23. *Christmas '88*, 1988. (also Plate 76)

[7] Translation taken from James Beck's *Italian Renaissance Painting*, New York, 1981, pp. 101-2.

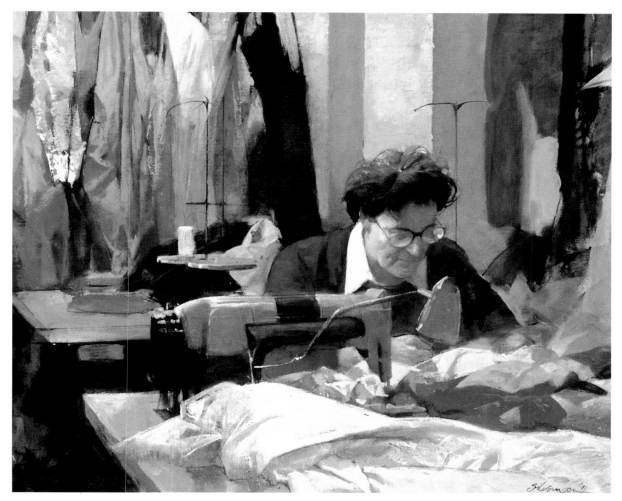

Figure 24. **Woman Sewing**, 1990. Oil on linen, 24 x 30 inches. Collection of Mr. & Mrs. Stephen Smith.

smiling young woman. We may read this work on several levels, including the obvious contrast of age and youth, or an older woman reliving her youth. This bifocal sensibility elicits a mixed feeling, one that, by turns, is sympathetic and critical. The central figure of the older woman reveals someone who stands erect, her hair groomed and arranged in a classic, ageless manner. A scarf is tied fashionably around her neck, and in one hand she holds her purse and a paper flyer, in the other, the handles of a shopping bag. She has not ceased to be a part of her culture, albeit an acquisitive one. She appears to be waiting expectantly for someone or something. Or perhaps she is halting for a moment to consider where to go next. Mirrored on the window behind her head are the words:

TODAYS WOMAN

Unlike the elaborately coiffured mannequins with their affected poses and elaborate gowns, which represent an idealized and unreal vision of femininity, Silverman's young woman in the background and the older woman in the foreground represent more pervasive images of today's woman. But there is also an underlying ambiguity evoked by the smiling young girl. Is her smile merely an open acceptance of life—a signature of youth—or is she making a sly comment on the inherent foolishness of it all?

In a series of paintings executed during the late 1980s and early 1990s, the artist shows us another part of the social order—the working woman. In the painting *Woman Sewing* (Fig. 24), he gives us a compelling portrait of a woman who still maintains her productive place in the world. She has learned her skills in her

youth and her work is a badge of honor. Ultimately she understands that her dignity and sense of self are assured, as she is needed and valued in the work force—as a wage-earner! This unknown person becomes a model for the countless women who worked second jobs to maintain a family or were widowed and became the sole support of their households. Silverman's affection for them is clearly in evidence here.

Other paintings present us with women in sidewalk cafes—glass-enclosed to protect against the inclement weather—either alone or in groups. In the painting *Lunch Date* (Fig. 25), an elderly woman with gray hair and lined face sits holding a coffee cup. Her face and hand bear witness to her age. Yet there are a newspaper and purse on her table, witnesses also to her involvement in the world. A similar painting, *100 Million Prizes* (Fig. 26), is equally concerned with a face seen through glass, almost like an exhibit case to preserve her timelessness. However, she is surrounded, almost overwhelmed, by signs of a commercial culture

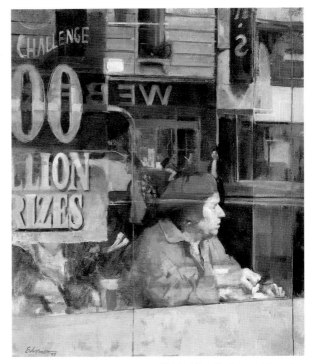

Figure 26. ***100 Million Prizes***, 1995. (also Fig.8, pps 19 and 20 in "Sight and Insight")

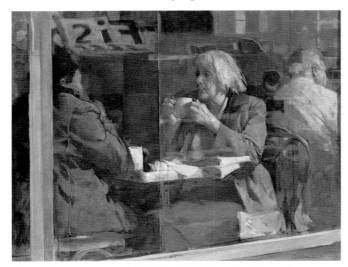

Figure 25. ***Lunch Date***, 1991. 30 x 39 inches. (also Plate 62)

that demands her attention and compliance. These are but a few of the complex compositions that reveal a sympathetic and searching view of these women. The juxtaposition of the reflected images on the glass and the interior portraits creates a fascinating dialogue about the relationship between an interior and exteri-

or life. (See "Sight and Insight," Page 13.) These older women are neither timeworn nor lonely, though these surely may be part of their lives. They seem to give off an aura of independence and self-reliance that betokens their having lived full and active lives, which are etched in their faces. They are survivors with grace and they are prepared to cope with whatever life will serve them now.

The contemporary artist who chooses to paint in a traditional representational mode (Fig. 27) is confronted with an overwhelming institutional bias. Often he is dismissed as derivative and irrelevant. Silverman's art serves notice that these aesthetic invectives do not apply to his work. After fifty years of Abstraction he perseveres in believing in the validity of representing the objective world through the prism of subjective scrutiny. Coming of age in the heyday of Abstract Expressionism, he has carved out a rich body of work that serves his visual need and his emotional attachments. Having used a career in illustration to survive economically, he also used his propensity for acute, psychologically sensitive observation to produce affective

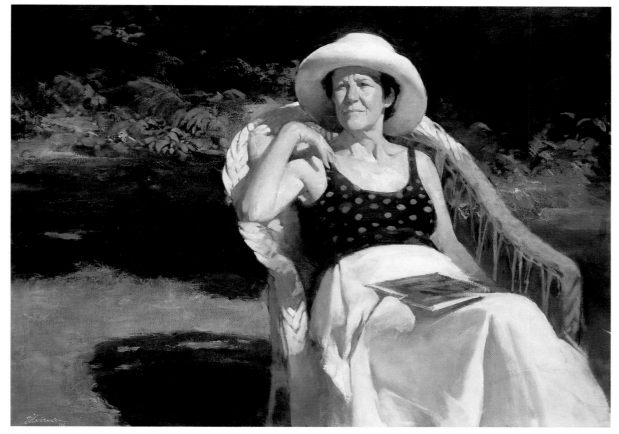

Figure 27. **Summer Hat**, 1997. Oil on linen, 30 x 36 inches. Collection of the artist.

paintings and drawings for *Time* covers and the Profile features for *The New Yorker*.[8] This has provided him with the skills to paint portraits for private commissions, and he has thus joined the great tradition of all past art. Furthermore, he is an aware artist who sees in the world around him human concerns that often are neglected in current art. It is no accident that his work has dealt with the emergent civil rights struggles, and he has understood feminist concerns almost since before they became programmatic. Now, almost subconsciously, he turns to the question of aging and mortality. But his is an empathetic involvement, one that focuses once more on women as exemplars both of our problems and our triumphs.

The last decades of the 20th century have seen some dramatic changes in the role of women in our culture, and these changes have generated conflict and confusion among women and men alike. We are still saddled with stereotypic conceptions of woman: courtesan, mother, angel, enigma. Nevertheless, in his paintings, Silverman has tried to see through these clichés to find the real people behind them. He permits us to glimpse some of the interior world of all these women and grants us at the same time some of his compassionate perception and painterly appreciation of them. He has made our separateness seem less painful.

[8] 28 drawings from *The New Yorker* have been acquired by the National Portrait Gallery of the Smithsonian Institution for its permanent collection.

Odyssey
by Burton Silverman

I write this as I'm about to enter my eighth decade. My life in art has been an extraordinary adventure and an incredibly fortunate one. I have been honored in one profession as an illustrator and have been recognized in another as a foremost realist painter. At some level, I look upon these accolades with a sense of disbelief. I wake each day thinking I'm just about ready to get something done, finally. I find myself approaching my odyssey in art, as always, with one foot in the air. This journey in the twilight of the 20th century is even more problematic because I see visual arts on the brink of triviality; but, at the same time, the prospects for the re-emergence of realism have never been brighter. Perhaps both of these impressions are the result of flights of moodiness and expressions of a bell curve of confidence that I believe most artists experience. For the moment, let me go back in time to try to describe what my odyssey in art has been about and...perhaps it will also illuminate what I have tried to do and what I still hope to accomplish.

My first real contact with art came at a surprisingly early age via the New York World's Fair in 1939. I was nine years old, but somehow my passion for pictures was full-grown. As a kid I read illustrated adventure stories, including the romantic novels of James Fenimore Cooper and the myths of King Arthur from *Scribner's* (which are still in print). What was special about these were the illustrations of N.C. Wyeth and Howard Pyle. These stories became more real through *pictures* that re-created the knights and colonial frontiersmen for my young imagination. I yearned to emulate these wonderful picture makers but had no idea how to do it.

My next encounter with art was in a book of reproductions of paintings from the Renaissance, including a remarkable group of works from 15th century Northern Europe—Flemish artists like Rogier van der Weyden and Jan van Eyck (Fig. 28). It was a gift from an older cousin, Gilbert Forrester, to whom I remain forever grateful. He read to me about the artists and the art of those distant places and times and exposed me to the glowing images that emanated from

these artists who cherished every blade of grass and every reflected light in their glorious renderings of religious lore.

But it was at the great 1939 World's Fair in New York that I really got a taste of what my calling was to be. Two vast "pavilions"—to a nine-year-old they were vast—contained five hundred years of Western art. I

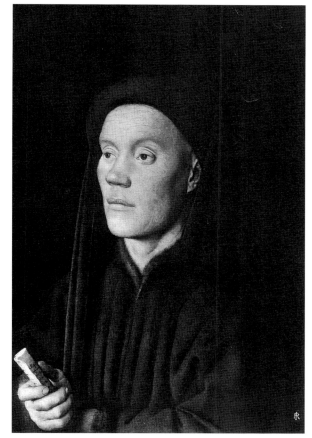

Figure 28. **Jan van Eyck**, *Portrait of a Man*, detail, National Gallery, London. Courtesy Alinari/Art Resource.

had never seen a *real* painting before this. The exhibitions were a virtual compendium of all the great national collections: the National Gallery of London, the Reyksmuseum of Holland, the Kuntshistoriche Museum of Vienna and the Mellon Collection of the National Gallery in Washington. Go down the list of great artists of history—Canaletto, Veronese, Titian, Rembrandt, Velasquez, Turner, Homer, and Eakins, to name only few—and you can understand my awe. This experience jolted my senses and stirred my ambition.

Figure 29. **Howard Pyle**, *Tales from King Arthur.* Courtesy Illustration House.

roamed the museums of Europe, the same feelings overtook me, and the art I had seen twenty-five years before remained both an inspiration and a challenge.) From that time onward, I was emotionally committed to the idea that I would be an artist.

At the same time I cannot recall any coherent plan to bring this about. For my parents, my ambition was a nightmare come true—this was 1939-1940 when the country had not yet emerged from the Great Depression—but somehow they found the courage to support me unreservedly. So off I went to Saturday art school at Pratt Institute and then to the High School of Music and Art which had recently been founded by that mercurial Mayor of New York, Fiorello La Guardia. My parents, continuously worried by my goal, had found the school for me, and they allowed me to travel the seventy minutes on the New York subway to get there—even on those dark winter afternoons—

In retrospect, it seems that all these artists' works became fused together in my mind as an ongoing image of amazing pictorial skills.

It also seems quite interesting to me now that, as a nine-year-old, I could not very well discriminate *qualitative* differences between Edward Burne-Jones's and N.C. Wyeth's pictures. Howard Pyle's richly graphic drawings of King Arthur's Knights seemed not far from an Albrecht Durer or Peter Breughel drawing. All of them presented an astounding ability to re-create the world with astonishing veracity, and so I did not discriminate between fine art and illustration.[1] I also thought that someday it would be possible for me to do as well. Was that nine-year-old so impossibly foolish as to compete with the whole of Art History? In defense of that child, let me say that I felt incredibly inspired, and my appetite for the world and its visual experiences literally exploded. I felt engorged, hopeful, even mystical. (Many years later, in my mid-thirties, as I

Figure 30. **N.C. Wyeth**, illustration for *The Rakish Brigantine* by James Connolly, *Scribner's* magazine, Aug. 1914. Courtesy Illustration House.

[1] Several years after he had given the prestigious Norton Lectures at Harvard extolling Carravaggio, the noted Abstract artist Frank Stella was to aver that all his life he thought that any picture that had a realistic image was just an illustration. This reminiscence came from someone who had had an art history education at Phillips Exeter Academy and Yale University and somewhere, somehow, must have seen a Rembrandt or two.

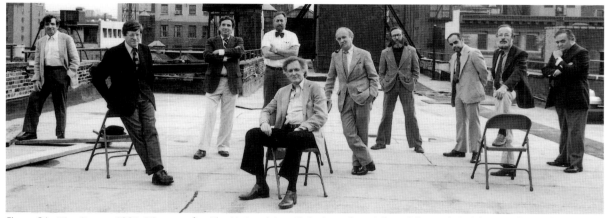

Figure 31. ***The Group***, 1981, 20 years after The National Arts Club show. From left to right: Herb Steinberg, Robert White, David Levine, Sheldon Fink, Daniel Schwartz (seated), Aaron Shikler, Harvey Dinnerstein, Julian Fishburne, Burton Silverman and Stuart Kaufman. Photo courtesy Guy Gillette.

and back again. But for me this was almost as much of an enormous awakening as the World's Fair. This was the beginning of my art training, most of it through the auspices of a small group of talented students—my new classmates—who grouped together to defend their drawing skills against the dogmas of the modernist education. It was then, and still is, part of the teaching mentality of this very progressive school, one that urged creativity without craft and self-expression without perception. A few of my classmates would become lifelong friends who remain constant in their devotion to the ideal of realist imagery.

This group of young men later became friendly with two or three other students at the Tyler School of Fine Art (part of Temple University) where the fragile beginnings of a group identity[2] arose and where one of the students there, Roy Davis, would later become our first gallery dealer. The bright promise of our talents for picture making at the Davis Gallery was to flame out in the "Realist View" exhibition in 1961 at The National Arts Club in New York. What was to have been a bold and even stunning revelation of the power of realist vision turned sour when it was utterly ignored by the established art world. We would be driven apart by the failure of the "Realist View" show and, probably more importantly, by the unacknowledged need we

Figure 32. ***Basque Man***, 1966. French National Tourist Bureau, Doyle Dane Bernbach.

[2] The artists who met at Tyler were Harvey Dinnerstein, Herbert Steinberg, Aaron Shikler, David Levine and sculptor Robert White. Five other artists were added later: Sheldon Fink, Stuart Kaufman, Julian Fishburne, Daniel Schwartz and Seymour Remenick.

Figure 33. **Coliseum in Arles**, 1966. French National Tourist Bureau, Doyle Dane Bernbach.

all had to establish our separate identities. The exhibition catalogue contained an essay about what I felt were the pretenses of Modernist aesthetics. It would be the first of a lifelong, futile attempt to dismantle a system of aesthetic values that I felt eliminated a level playing field in the world of painting.

The demands of making a living grew more insistent in the years after I was discharged from the Army following the Korean War. In the Army I made dioramas (little stage sets, really) that were used to promote home front morale. After the war, I free-lanced cartoon-like illustrations (a style I picked up rather easily from the print media) and later worked as a layout and paste-up artist for the *New York Post*. This was the perfect job—working only three days a week, I had another three and sometimes four days to paint. However, the restricted creativity of promoting the sales of ad space in the *Post* led me to look elsewhere for a way to survive. Ironically, my second one-man show at the Davis Gallery was to point the way. The announcement for the show had a drawing on the cover, a study for one of the paintings. It was seen by Jerome Snyder, the Art Director of *Sports Illustrated*, who called and asked me to work for him. I decided to leave the *Post* for good.

My moment of celebrity and sudden wealth was brief indeed. Snyder was replaced a year after I started working for him, and I was out in the cold, along

with other of the artists who had worked under his direction. So I looked elsewhere for work, such as in book illustrations, record album covers and the occasional small magazine article. Gradually, because of my drawing abilities, I found myself increasingly sought after in the world of Illustration. At the same time, I was still painting and still exhibiting. It is remarkable now to consider how much time there seemed to be back then. There was time for everything and the days and months were crowded with events and changes. I remember the 1950s quite differently from the generally genial era of soapy songs, two-toned loafers, and teenage romance. For me and many of my friends it was the nightmare world of the Rosenberg

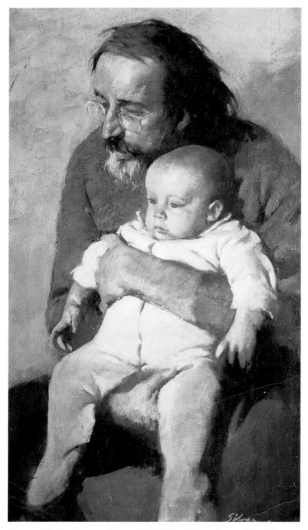

Figure 34. **Father and Son**, 1973-74. Oil on linen, 26 x15 inches. Collection of the artist.

Figure 35. **Woman Singing**

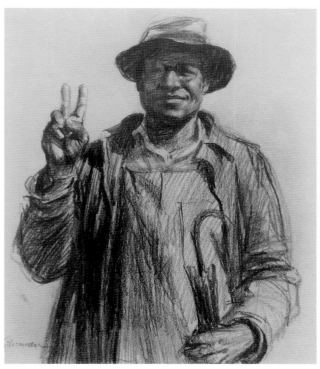

Figure 36. **V for Victory**

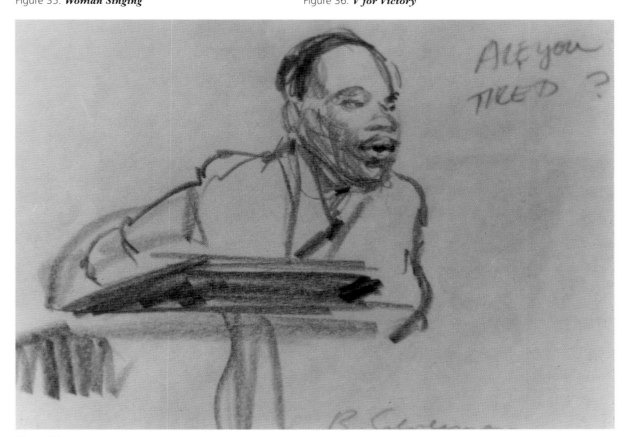

Figure 37. **Martin Luther King**

Drawings from the Montgomery Bus Boycott, February-March 1956. Courtesy Delaware Art Museum.

trials, the intensification of the Cold War and the death-dealing hand of McCarthyism. Yet it was redeemed when I went to Montgomery, Alabama, with Harvey & Lois Dinnerstein to draw the bus boycott led by Martin Luther King, Jr. (Fig. 36). It was an historic event that signaled the start of the Civil Rights struggle and bit of light in a dark decade. I was married for the first time in 1957, when I was a member of the *Post*'s staff, and my wife and I went off to Europe on a four-month-long tour of the great museums and great capitals of Western Europe. By 1962 I was painting for a second show at the Davis Galleries and doing free-lance illustrations, and in 1964 I began to teach at the School of Visual Arts. That year I went to Europe for another go-round of the great museums, as well as to search for romance after my marriage had unravelled.

By 1968, after a long period of living alone, I met

Figure 38. **Who Am I?**, for *Redbook*, 1964. Collection of Irving and Frances Phillips.

Claire and in a very real sense it was the beginning of a second life. We were married in 1969, and she became my most consistent model, my most responsi-

ble critic, and my most unswerving supporter. We had two children in the next six years, and I became a pioneer playground father. My family became the resource for many paintings both in the galleries and in my illustrations (Figs. 34 & 38) and I was again beginning to find more visible illustration commissions. *Esquire* magazine began using my art with some regularity, and it is important to note that they were usually paintings and drawings of real places and real people. Often I was given assignments to do portraits, which then led to *The New Yorker*'s hiring me to draw the subjects for their Profiles feature. (Figs. 39 through 42)

Here again the change was significant, because I was being called on to use skills that had been trained and honed for painting. More to the point, my art was sought after because it was realistic and straightforward. This experience confounded my fears of what illustration would ask of me—to make images that would ultimately prettify and trivialize my painting. Much of the perception of illustration, "commercial art," then was as throw-away stuff, dealing with romantic fantasies and soapy subject matter that was unworthy of serious consideration for an artist. "Illustration" was more than a dirty word for the fine artist. It implied an inferior form of expression and somehow a betrayal of one's gifts. I even separated my studio into two parts and made one space for illustration and the other for painting. But magazines were changing. The art directors were becoming more interested in reality-based imagery, and they began to look for painterly qualities in the illustrations.[3] Even the so-called "women's" magazines like *McCall's* and *Redbook* began to let go the Al Parker and Coby Whitmore kind of art and to seek other people who could give more urgency to their images. Morton Roberts and Daniel Schwartz were at the forefront of this change. Soon other friends from the Davis group became involved

[3] For a more comprehensive history of American Illustration see *The Illustrator in America 1880-1980*, Walt & Roger Reed, Society of Illustrators, 1984.

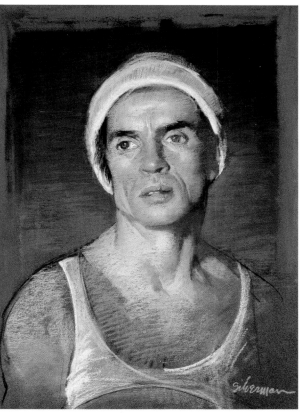

Figure 39. ***John Cardinal O'Connor***, April 1987. By permission of *The New Yorker*.

Figure 40. ***Rudolph Nureyev***, for "Profiles," Jan.1993. By permission of *The New Yorker*.

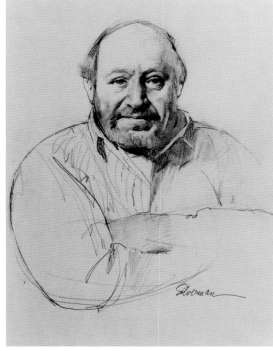

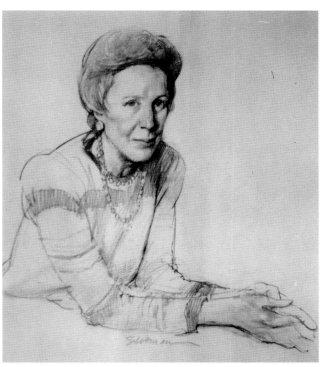

Figure 41. ***Herb Graf***, film buff and archivist, "Profiles," Nov. 20,1989. By permission of *The New Yorker*.

Figure 42. ***Rosamond Bernier***, "Profiles," Jan. 1987. By permission of *The New Yorker*.

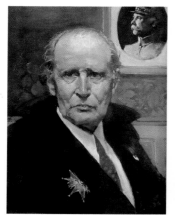

Figure 43. ***Francois Mitterand***, for *Time* "Chronicles," 1992.

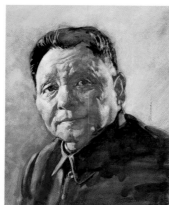

Figure 44. ***Deng Zhaoping***, *Time* cover, Feb. 1979. By permission of Time, Inc.

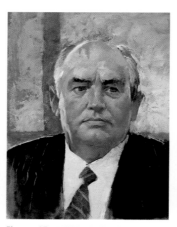

Figure 45. ***Mikhail Gorbachev***, for *Time*, "Man of the Year" runner-up, 1987.

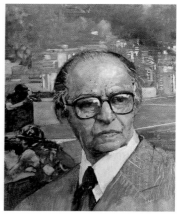

Figure 46. ***Menachem Begin***, for *Time*, 1983. Courtesy Society of Illustrators.

with illustration. Harvey Dinnerstein[4] did reportage for *Esquire*, like the Eight of the early 1900's, only better, and David Levine created his brilliant caricatures. I believe Daniel Schwartz almost single-handedly changed the character of illustration by bringing to the discipline a sense of classic rendering and dramatic exploitation of the brush stroke. This was the legacy of the fine art world that had been temporarily deserted by illustration during the fifties. Old-fashioned "painterliness," (derived from 19th century art) was now modified by a bold use of formal play with the materials of the paint which, when combined with a devotion to realist imagery, produced a new look in the last three decades of American illustration.[5] I was lucky enough to share in this wonderful time. With the demise of so many storytelling magazines and other print media (television and computers have dramatically altered the market for them), historic, traditional painterly illustration has almost disappeared. I viewed these changes with a mounting sense of dismay. In 1991 I was elected to the Society of Illustrators Hall of Fame and was, coincidentally, on my way out of the profession.

Illustration is still a dirty word in the world of High Art. Five hundred years of Western art, which has illustrated everything from the Crucifixion to the invasion of England in 1066, the victories of Phillip IV and the agonies of the French Revolution, have been sanitized by referring to these pictures as "narrative" art. An abhorrence of "illustration," a catchword for an image that the viewer can apprehend without the interpretation of a critic, is now firmly embedded in the modernist aesthetic.[6] Indeed, it has caused me to hide my career as an illustrator, lest it forever mark my painting as ordinary. I avoided any mention of my illustration career in my biography for brochures for exhibitions. In recent years I've begun to acknowledge this career in speeches to various workshops throughout the country which were generally composed only

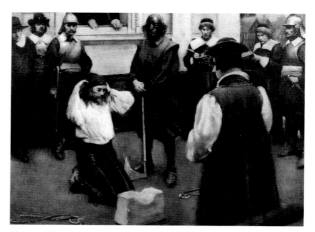

Figure 47. ***Execution of Charles I***, for *The London Sunday Times Magazine*, 1971.

[4] Dinnerstein's painting of Joe DiMaggio called *The Swing* was commissioned by *Esquire* magazine. It has probably become the single most reproduced painting of a sports image in the past 30 years.

[5] This was by no means a total picture of Illustration and there was, and is, a very wide range of looks and styles in the profession. In addition, there is still much arguable controversy about the nature of illustration as art. For a case to be made about Norman Rockwell as a 20th century *genre* painter, see *Norman Rockwell*, Thomas Buechner, Harry N. Abrams, 1969.

[6] A review of the Lucien Freud Exhibition at the Metropolitan Museum of Art in the January 1996 issue of *Arts & Antiques* by Hilton Kramer has the following sentence embedded in his moralistic distaste for Freud's art: "In the end it is the image of *illustration* rather than its *painterly realization* (emphasis added) that is relied upon to sustain attention" and ends this way: "And if that is the case, then its is yet another reminder that it is as an *illustrator of* our anxieties rather than as a master of the art *of painting* (emphasis added) that Lucien Freud exerts a special appeal."

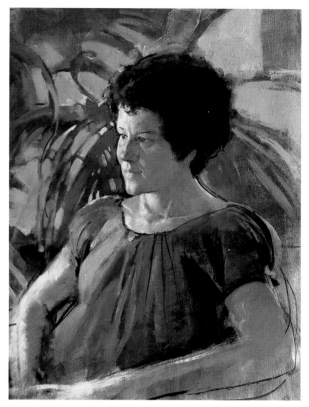

Figure 48. **Study for Remembrance**, 1975. Oil on panel, 16 x 12 inches. Collection of the artist.

of gallery artists. In these settings I was pleased and surprised to find that both of my careers were held in respect and admiration. To these groups (as well as to illustration-based seminars) I have said that my best training in the craft of painting came from doing illustrations because it taught me to compose my paintings more effectively, to improve my color, and to be ruthlessly selective.[7] These very fundamental pictorial processes were never dealt with in the few years of formal study at the Art Students League in New York during the late 1940s. Reginald Marsh, Julian Levi and, to some extent, Louis Bouche, with whom I studied for short periods of time at the Art Students League in New York, were all pretty much forgettable as teachers.[8] Having said all that, I must put in this caveat: that techniques and formal skills do not necessarily make great art and a good deal of illustration, past and present, is not terribly interesting largely because the subject matter was not terribly interesting. In addition, there are implicit demands to idealize images—of both people and places—and to make pictures blandly appealing and inoffensive, severely limiting the character of this art. The same might have been said for much genre painting of the last three centuries. But my point here is that the aesthetic separation of illustration (storytelling) from the art of painting is at the heart of the critical deconstruction of the historical character and function of what we call Fine Art.

So, my career as an artist has veered between these two worlds, but it has never been diverted from the self-image I held very early on. This may be simply put: I have loved the ability I have to represent the visual world in paint, and the magical way in which it can transform experience. It is a dynamic, self-renewing process that has become increasingly demanding over the years. In consequence, I have struggled to produce works that would synthesize what I have learned from the past with things I know and feel about the present.

When I decided to stop taking illustration commissions almost eight years ago—something of a two-way street, as it happens, since many areas of work were fast disappearing—I discovered a new source of energy. Much of my youthful enthusiasm returned and, although I had been exhibiting and painting regularly, the focus on my *interior* world intensified. As a painter, my agenda is far more autobiographical and is directed toward more ambiguous storytelling. In part this is because my "stories" are not linear and do not have a plot line to illustrate. I also feel a kind of urgency and, yes, even a sense of greater importance—to paint my own pictures and to explore ideas of wider concern than are generally commissioned in Illustration, despite my own good fortune to find the best of them. This is for me but one of the significant differences between painting and illustration. Another is that a painting of mine is now intended to be seen directly and not through the screen of reproduction.

[7] An interesting article in *The New Criterion* (September 1996) by Michael J. Lewis entitled "Homer, Hopper and the Critics" stressed the fact that critical appraisals of the work of these artists completely avoided the issue of how picture making skills were shaped by their work as *illustrators*. He goes on to say "Yet historians, founded on the myths of modernism, are still trying to fit these figures into the old scheme."

[8] Except for Reginald Marsh, their names, and to some extent their work, have also slipped into obscurity.

Figure 49. ***Nude***, 1949.
Pencil, 12 x 5 inches.
Collection of the artist.

And, finally, the picture is designed to stay around longer than a week or a month. This is a very different visual and emotional experience than looking at art in a magazine.

Recently, I feel there have been new developments in my work that reflect my renewed sense of purpose and more integrated painting life. I still paint portraits but now for living rooms or boardrooms. Despite the bad rap on current portrait painting, I think it is possible to make a good painting while fulfilling the demands of private commissions. After all, just look at the major museum collections around the world to see how much great art turns out to be a portrait. All the years of drawing (Fig. 49) and painting that I have done both as an illustrator and painter have now been put to the service of dealing with my own subject matter, which has become more emotionally and pictorially challenging. I've continued to paint themes that were present in past work, but I am now exploring them differently. For example, the paintings of the strippers changed from performance (a stylized erotic exhibition) to performers and, in so doing, stretched the traditional concept of the nude (Fig. 50).

I have pursued the theme of the cafeterias and fast-food places with their plate-glass windows reflecting the exterior world superimposed over the interior reflections of their patrons. I found in my country studio a new place to discover landscape that was both traditional and unusual. And the synergy between interior and exterior worlds has become intoxicating. I have searched for different ways to paint the nude out-of-doors and to once again explore the figures on the beach that I had painted for so many years in Italy. I have painted older women who are often left out of the iconography of representational painting. Many years ago I saw Rodin's nude sculpture of an old woman, seated, with her shoulders rounded and her breasts flattened. It was a startling image. I have thought of that piece many times since, for what it sug-

gested about human frailty and for the boldness of the artist to sculpt it. I have painted older women at work because they seemed to belong there as much as men. And, possibly, because they reminded me of my mother. I continue to paint single, portrait-like figures because they have been the most consistent source of interest and fascination for me. Very early on in my life, I fell in love with the landscape of the human face, where all the emotional states of life are to be found, and that love affair has not faltered. In an age where, with rare exception, paintings of people *without distortion* or woeful states of angst have disappeared from museum collections, I see an increasingly clear role for

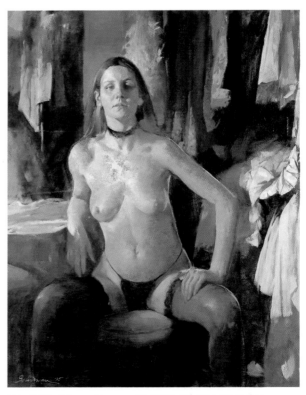

Figure 50. ***I Am a Dancer, II***, 1995. Oil, 30 x 24 inches. Collection of the artist.

myself—to catalogue those images of our world as part of my ongoing love of life around me. But for the moment it seems only *photographs* of people are allowed into museums.[9] It goes without saying that I, and many

[9] Robert Mapplethorpe is the most recent high profile example.

other serious realist artists, feel excluded.

Over the years, since the first essay I wrote for the *Realist View* catalog challenging the assumptions of Modern Art, I had become less contentious on the subject because I felt my role as a *painter* was work enough and all I could really do was to make my paintings better. The idea of "protest" seemed not only whining (about being overlooked), but a waste of energy in the face of something that could not change in the near future. Of late, that feeling has changed again, because the climate has worsened for realist art despite all the apparent changes for the better. The climate of art is so bizarre that many people think of art as rather silly and frivolous. This hurts all art, *and all artists*. I feel that the *aesthetics* of realist art—that is, the validity of its underlying assumptions—has still not been accredited in the major museums and art magazines. These are the powerful institutions that control thinking about art.[10] Against my better judgement, I have become more insistent in my attempts to cut through the rhetoric of current aesthetic theory. I've sought to publicly examine exactly what I think we have seen in a century of Modern art and how it has impacted on our sensibilities. At the same time, and because the issues are twofold, I have also tried to establish a set of criteria[11] for assessing the merit of realist representational painting. This is hubris, to say the least, and difficult at best.

In 1994 I volunteered to run a symposium at the National Academy in New York which I hoped would raise the possibilities of a broad based "realist renaissance" as a viable alternative to Modernist art. Although there was a large and enthusiastic audience, the symposium failed to elicit the central issue I faced: Why, in a century of experimentation and innovation, did a group of dedicated and talented painters still persist in using traditional imagery and painterly devices

Figure 51. **Demonstrator**, May 1968, Columbia University Student Protests. Charcoal, 17x 13 inches. Collection of the artist.

for their expressive platform? I was hoping to find a consensus that would validate the superiority of realist iconography. Unfortunately, not much of an answer was forthcoming, though many in the audience felt the forum had been useful.

In the fall of 1996 I gave support to a group of largely younger artists who organized a protest at the Whitney Museum in New York, the purpose of which was to open the museum to a more balanced presentation of realist art, especially in their Biennial exhibitions. While there was a very strong outpouring of feeling, from many artists, none of whom necessarily

[10] In an interestesting turnabout, the Whitney Museum, in May of 1998, mounted an exhibition of Andrew Wyeth's early and late works. The catalogue for the exhibition made an attempt to credentialize Wyeth as a sort of closet abstractionist by showing early florid and loosely imaged watercolors. This was not unlike an exhibition at the Whitney in 1968 to similarly validate J.W.M. Turner as a covert, but clearly identifiable, Abstract Expressionist.

[11] See "What Makes Art Great" by Burton Silverman, *American Arts Quarterly*, Spring 1995.

shared either a stylistic or philosophic commonality, there was no support from the art-loving public. Passers-by in front of the museum, some going in to see the big Edward Hopper show going on at the time, did not even stop to listen to what many very persuasive speakers were saying—fearful, I suppose, of getting "involved." Or perhaps it was just that the words did not mean anything and that it was all just more art babble. National Public Radio shunned the issue in their local station WNYC. And the protest was brushed aside—(as indeed they had been when a similar protest was led by Edward Hopper in the early 1960's)—by former Museum director David Ross, who met these objections to policy with a deftness only available to people sanctified by privilege and inured to criticism.

In 1998, continuing this Odyssey, I gave a couple of lectures[12] on the theme of color and design. It was an attempt to illustrate the course of 20th Century art, where form and content had been separated, leaving color (and design) as the primary vehicle for expressiveness. This single deconstruction had made the complex art of picture making into a play of surfaces and colors *alone*. As I saw it, this was the triumph of *decoration* and the ultimate democratization of art. *Anyone* could become an artist—because it was relatively easy and often it only meant just saying you were

one. My purpose was to clarify Modernist art for people who would say "I don't know what I'm looking at!" and enable them to understand the difference between realist work and other 20th century art that seemed so elementary and yet so confusing. By showing the devolment of mid-20th century art to be a *devolution* into pure decorative arrangements (powered by the late paper cutouts of Pierre Matisse) I hoped to give people answers to that query and in the process help to counter the otherwise *unchallenged* authenticity of that art.

At the same time I also understood how *pleasurable* that painting was, and is. Pure color, and all the visual combinations that are possible with it, can be continually fascinating and enjoyable for their own sake. Color can also provide the stimulus for endless sets of "meanings" which can now be supplied by each individual viewer and is thus *totally* subjective. (The spectator has indeed become the artist!) Nonetheless, these objections to the powerfully seductive art of this century are ultimately pointless. To try to challenge such a "fun" art experience, and one that distracts us so seductively, with *rational* arguments, is a losing game.[13] And more importantly, the enormous increase in *money values* attached to classic abstraction almost insulates it from criticism.[14]

A friend wrote to me after my 1998 lecture in Denver (where I made the case for viewing 20th century art as decoration):

[12] At a "Conference on Color" in Williamsburg, VA, sponsored by the Inter -Society Color Council, Feb 1998, and at the Merrill Gallery in Denver, April 25, 1998.

[13] Post-modern aesthetics have now downplayed the supremacy of color, and have deconstructed the authority of painting so that it can deal with the flood of disparate materials and objects that flood the art environment. A new cry was heard: painting is dead!.For more on this notion see Philip Menand's review of the play "ART" in the May 14, 1998, issue of *The New Yorker*.

[14] Back in early October of 1993, Morley Safer did a "60 Minutes" segment on what can be generally called an exposure of the "Emperor's New Clothes" syndrome in our current art world. Safer presented the works of several well known and highly regarded artists and questioned their validity in a tone of humorous skepticism for what he regarded as their frivolousness and jokey pretenses. The response from the Establishment art world was swift and unremittingly vicious. From the *Village Voice*, to *New York Newsday* to, of course, *The NY Times* the cries of know-nothingism, and Philistinism rose in tandem to attack his commentary. In the final week of October Safer was, according to *Newsday* put in his place by Jenny Holzer (who at last view *writes* her images with pseudo-profound little one-liners) on the PBS Charlie Rose Show, when she remarked, "But you abused your platform by saying that because you don't get it, the work's a fraud." Michael Kimmelman, writing in the *Times* (Sunday Arts Section, Oct. 17,1993) allowed that some art writing "in defense of much meager contemporary art had become a kind of wall or barrier so high that only a few could scale it" but that "*no one who genuinely cares about art and esthetics* (emphasis added) can feel anything but alarm while watching lampoons like the one broadcast into 17 million households the other night." To summarize these comments in a few sentences is difficult except to say that if you challenge the assumptions of Modernist aesthetics you are either a revival of the "booboisie," a Phillistine attacking progress through ignorance, a covert artist attacking a style you don't like, or someone who doesn't care about art.

"Rothko tries to heighten our sense of particular colors; he uses them for color's sake not to describe people and things. Do you really want to say that using color and/or design as ends in themselves[15] is less legitimate than depicting humans and their interactions? That sounds almost like a *stricture*." (emphasis added) I confess to having that "stricture" because while I find the play of colors and shapes diverting and occassionally pleasant, I find no special insights in them nor is my vision of the world around me enhanced. In all other arts, the life enhancing preceptiveness of the spectator, the audience or the reader is significantly affected. The visual arts alone have become, well, a joke. I cannot decide which set of colors are more moving or profound or insightful than any other set of colors. Paint alone is—well, just paint. Unlike the critic, Arthur Danto, I can tell the nature of the art experience through its *appearance*;[16] I do have a kind of value system that acts to discriminate good from bad, both in pictures and in life. Cutting-edge art—and that includes any and all free association with objects that may have been assembled for expressive purposes—leaves me in an emotional and intellectual vacuum. While it may be interesting and important for the practitioner it is not philosophically or psychologically important to me. I feel that much of modernist art has been involved with rudimentary formal exercises and to call it *High* Art is a wry twist of irony. And yet, it is also pointless to object to the art of our time[17] (if one can even begin to categorize it so simply) because it has so much history now that it is an unchallengable, ineradicable fact. Utlimately the real issue for me is to continue to paint and improve, to deepen my art as much as I can and leave history alone. I am curious to see the kind of art that will emerge in the 21st century. I hope that it will be more rational and, in my view, more successful.

This mini -biography is all about who I am as an artist. I wish I could believe in this century of decorative innovation. It would make life so much easier. I remember way back as a youngster in my first classes at the High School of Music and Art, where under the coercive urgings of a teacher, I tried to use paint to just "express myself" without any depiction of object or place, person or thing. I grew faint, almost nauseated, and unable to breathe! But at times I do feel feel like an "outsider"—an artist outside the pale of Abstraction—whose "style" also doesn't fit any of the accepted revivals of Realism; neither Photo, nor Close-an, nor Nouveau. Nor do I feel comfortable with another kind of so-called Realism where opulent colors transform landscape and people into renditions of a "pretty" world that is endlessly the same. It is important at this point to say once again that the problems for realist painting are quite complex. I do not wish to impose an aesthetic straightjacket on anyone. I cherish the truly rich diversity of representational or realist art. But I think that Realism has to progress, somehow, from "representationalism" to something more, but I'm not at all sure what that "more" might be. I continue to feel that the goal of my art is to create paintings that satisfy the enduring instincts we have to see images of ourselves, and also to search for the meaning of those images.

[15] An obituary for the highly acclaimed Minimalist artist, Donald Judd, in the Feb.14, 1994, issue of *The NY Times* describes the artist's view that the art object's purpose was not to serve as a metaphor for human life, *but to have a strong formal life of its own*, (emphasis added) something he frequently called "specificity." His summary position is quoted here as "Art is something you look at."

[16] In *The New Yorker* review cited above, Arthur Danto is described as one who still "believes that art has essential qualities; he just doesn't think those qualities reside in its appearance." This would apply, I suppose, to feces displayed in a plastic box (a show reviewed seriously by *The New Yorker* several years ago). Certainly you could not tell from its appearance what those essential qualities were. When are feces not feces? When it's in an art gallery.

[17] I have only briefly mentioned the elevation of the photograph to museum status. I believe this is another market-driven value, which has created a new aesthetic based on the assertion that the photograph is a *new form*. (I guess Monsieur Daguerre, circa 1832, was a premature modernist.) I do resent seeing a photographic image, rather than a painting, of real persons and events as being the only " acceptable" images of the external world.

I am stuck with my passion for the objective world, for the constantly shifting shades of meaning to the events in my life, to the states of being of the people I paint, and to the persistent need to get it right. I am wedded to who I am. I continue to make paintings of people and their moments in our time because *I am* of that time; out of that I hope to make pictures that are timeless. I love an art which allows me to document my place in this mix and I trust the people who love to see it. I love the fact that this art might somehow affect the way people see, and thus open a window on the world. And I love the fact that there are more and more young people out there who still want to learn how to make a flat two-dimensional surface come alive with three-dimensional magic. This is my past and my future. It has its own logic and, finally, its own sense of fulfillment.

Catalog

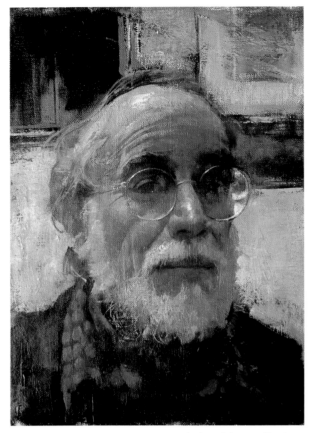

Plate 1. ***Self Portrait***, 1995. 14 x 12 inches. Private collection.

I've often used myself as a model both to record the passing years and perhaps, more importantly, to begin painting again after long lapses when I was involved with illustration. The shift to painting needed a kind of jump start before I could begin larger, more ambitious compositions. The self-portrait allowed me to get my painting legs back, since I could offend no one if it turned out badly. In some ways it also freed me to explore and test out pure painting ideas that I had mused about while I was making illustrations. The *Painter's Hat* was done in my country studio in the summer of 1990 when I was finishing several paintings for my November 1991 solo exhibition at the Capricorn Galleries in Bethesda, Maryland. It was, however, different from those I had done as a warm-up. Tired of working from photos, I suddenly felt the need for a live model, and quickly. I was the only one available on short notice. I think this painting reveals a lot about my feelings, a mixture of confidence and anxiety that is often a part of the preparation for a show. Another self-portrait (left) was done five years later, and also while preparing for an exhibition—my first at Gerold Wunderlich & Co. in New York. This small picture is also a kind of search for oneself, both artistically and chronologically.

Plate 2. *Painter's Hat*, 1991. Oil on linen, 24 x 30 inches. Collection of Dr. and Mrs. George Marak.

Plate 3. ***Baby***, 1972. Drawing from the artist's sketchbook,
5 x 4 inches.

Passage is one of my favorite pictures for many
reasons, not the least of which is that it is of my
son. Beyond paternal pride, though, I feel it came off
just as I had hoped. Bobby was at a turning point in
his young life. I knew he loved to draw and paint (and
he does have considerable talent). But his dreams lay
elsewhere, in the theater. Nonetheless, posing in his
father's studio roused in him some questioning of him-
self that I think I touched on in this portrait. The title
Passage came to me because I sensed Bobby was hop-
ing to find a path to the realization of his own dreams.
It was also a play on the idea of a rite of passage,
something everyone goes through at some time. The
painting was born of this idea, but I found myself
enjoying it on other levels. It was just fun to paint the
still life of brushes, paint tubes and palette in the fore-
ground. I also found that a painting on the easel
behind him could suddenly provide sharp contrasts of
patterns and shapes for his head and make it graphi-
cally more forceful. But with this device the painting
suddenly began to blur the integrity of the pictorial
space. The intended "realness" of the figure of Bobby
in the studio was compromised by the intrusion of a
secondary spatial perspective of the figure in the
painting on the easel. This bit of ambiguity pleased me
and continues to do so.

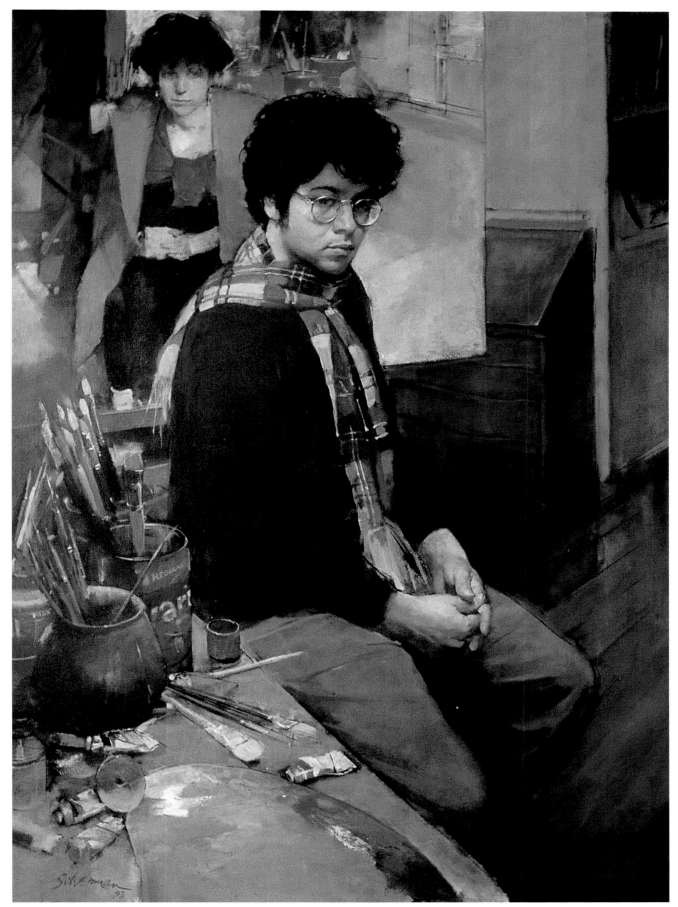

Plate 4. **Passage**, 1992. Oil on linen, 40 x 30 inches. Courtesy Merrill Gallery.

I became a father late, at the age of 44. This little rite of passage of my own opened up new emotions and, consequently, affected my art as well. My family became my models. I painted both of my children frequently, but both were difficult models. The attention spans of 4- and 5-year-olds are not terribly long. At age 7 my daughter, Karen, was often poised between her precocity on the piano and her child's world of fantasy and play. The Cabbage Patch doll was a wildly popular item at the time, and was her constant companion. *Piano Seat* was born out of this conflict of affections. In painting her this way, seated at the piano, I was faced with a problem. The light in the room was bright and diffuse. It had no focus. I decided to paint her in this spot anyway because it would lead to some challenges, particularly in how to make the head feel sculpturally solid. I was reminded of the way the Northern European Renaissance painters, like van der Weyden, used to render their portraits without a strong focused light but still produce an image of sculptural weightiness. But their style was different and probably far more suited to this kind of imagery. I found the portrait would appear more three-dimensional, even though rendered without a strong chiaroscuro, if I used very simple, flat shapes in the background to contrast the finely rendered delicacy of her features. This painting satisfied me as much with its painterly solutions.

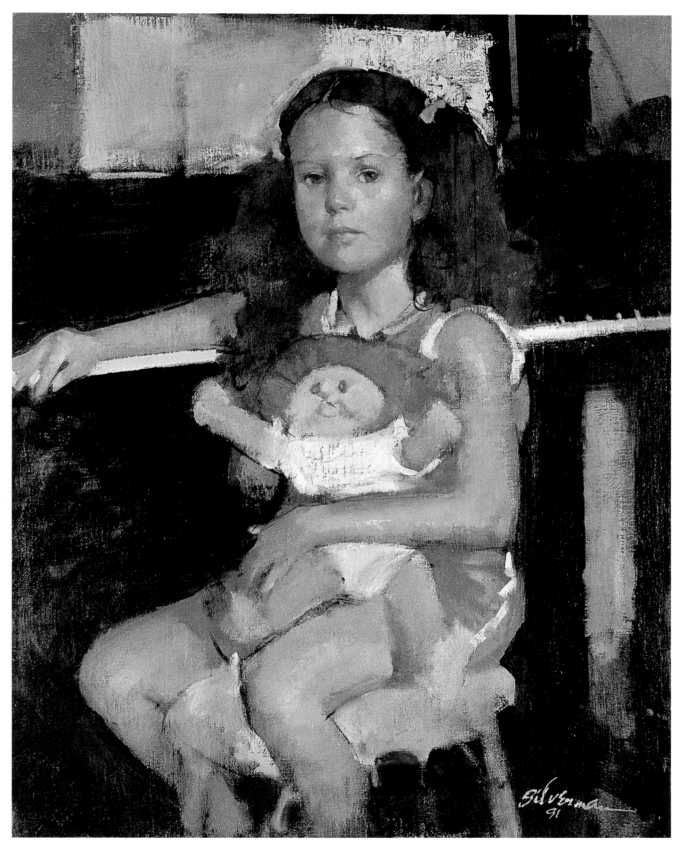

Plate 5. *Piano Seat*, 1990. Oil on linen, 20 x 16 inches. Collection of Roger & Marcia Simon.

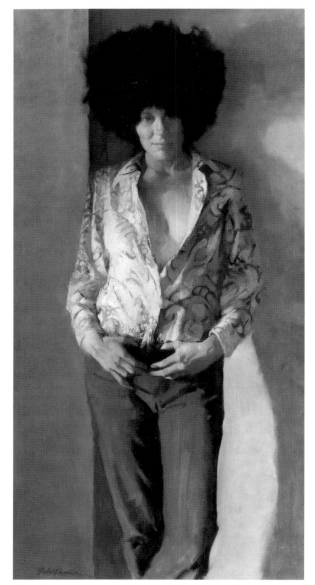

Plate 6a. ***Remembrance***, 1972. Oil, 50 x 32 inches.
Collection of the artist.

After the third or fourth summer in Italy, my wife, Claire, began doing patchwork quilts as a way to fill time while I worked on paintings in the small studio nearby. On occasion she would halt her work and look up briefly, as if planning the next color or considering something more problematic. The painting is entitled *Patchwork*, which is perhaps a play on the word, since Claire was also living her life with some patches. Her career as a psychologist had taken a long pause, and though she never considered not being a full-time mother, I think it left her with some feelings of regret. We had, after all, come together as a sharing couple, and for the early years of parenthood I was a full partner in child-rearing. But I was far more able to continue working than she. I painted this picture partly to preserve that time and those emotions. The small scale of the picture is a perfect analogue to its intimate quality. This differs strongly from the earlier painting on the left, which shows Claire immediately after the birth of our son and where the strong chiaroscuro provides the drama of the image. It is also arresting because of the dramatic Afro she wore at that time. But her stance and her mood suggested something else: the inference of a reassertion of her femininity in the aftermath of motherhood.

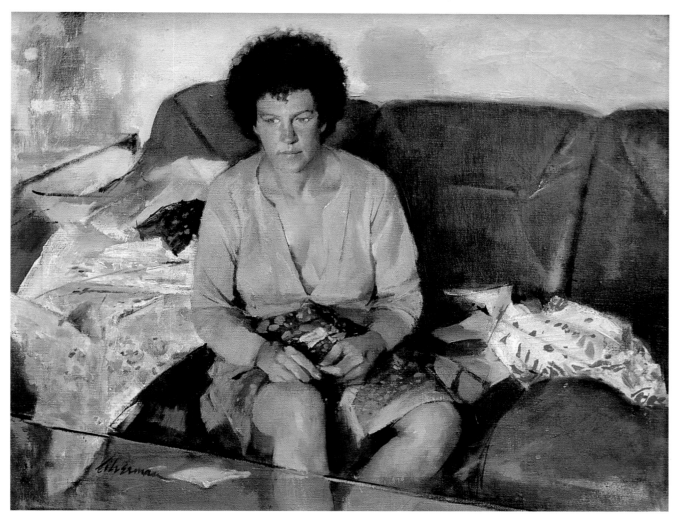

Plate 6. **Patchwork**, (series) 1982. Oil, 24 x 18 inches. Collection of the artist.

One afternoon during my weekly class, a friend of one of the students visited with us. The man was not especially distinguished, but he had such an agreeable manner that I was prompted to ask whether he would come to pose for the class. He agreed, and we set up an appointment for him to return. Initially I was drawn to the wonderful play of light on the jacket and the dark curtain behind him, which, of course, made the picture quite strong. Not surprisingly, something else happened. The "something" was in this pose and the tilt of his head, which seemed to express a kind of smug self-satisfaction—but not quite that either. I painted the head with an indefiniteness on the right side of the face as a way of expressing this ambivalence. This relatively large painting emerged. It was exhibited at the National Academy Annual in 1993 and at the Merrill Gallery in Denver in 1998.

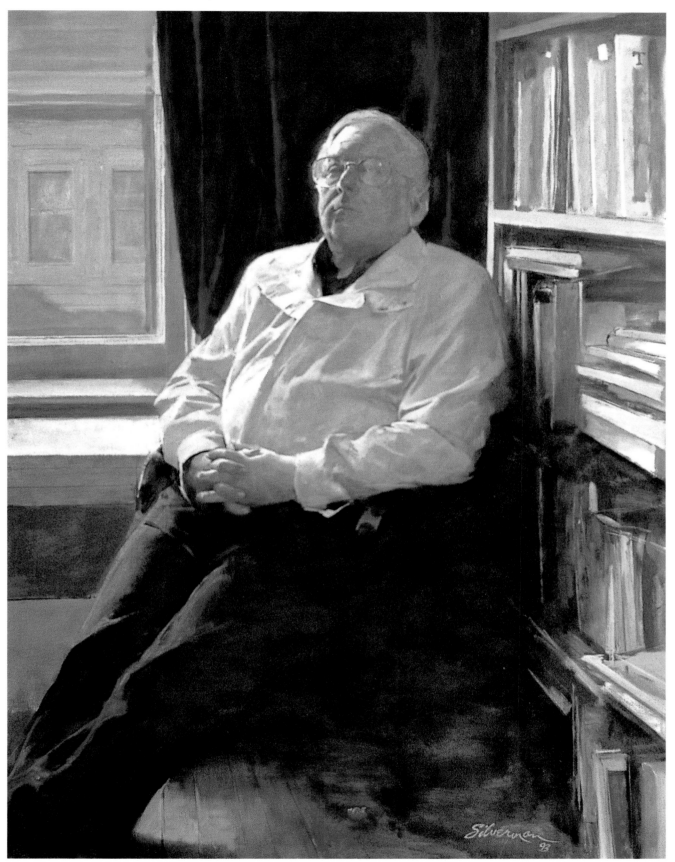

Plate 7. ***The Visitor***, 1992. Oil on linen, 50 x 36 inches. Courtesy of the Merrill Gallery.

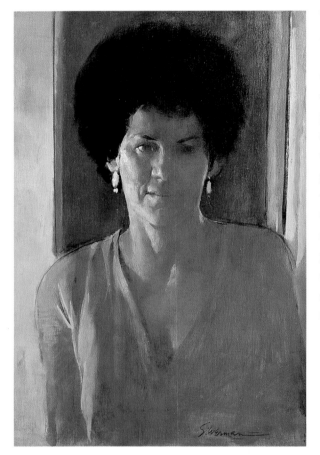

Plate 8. ***Claire in Orange Shirt***, 1978. Oil on panel, 14 x 12 inches. Collection of the artist.

In the Studio is the last of the paintings of Claire that I executed in the 1980s. It was not completed until 1996, after I had repainted the image many times, turned the painting aside, abandoned it and even considered destroying it. But I finally resolved the picture to my satisfaction. It was unusual for me to take so much time with a picture, painting and repainting the image. It represented a struggle to make the picture work formally (its color and paint qualities) as well as emotionally. The image of Claire was almost too passive, but I finally got the feeling of thoughtfulness and warmth that I wanted. The study (left) was painted several years before to explore the play of light coming from the side at an extreme angle. This was a small departure from the way in which light was used in most of my other work.

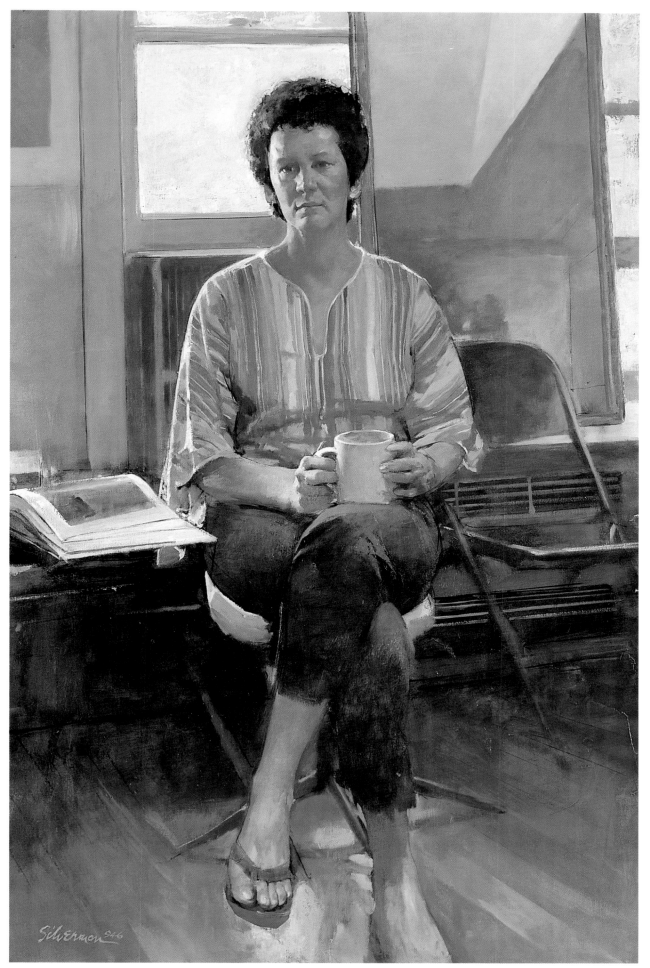

Plate 9. *In the Studio*, 1989-95. Oil on linen, 44 x 30 inches. Collection of the artist.

Plate 10. **Study for Reflections**, 1987. Pencil, 12 x 7 inches.
From the artist's sketchbook.

eflections was first shown at the National Academy's annual exhibition in 1989. Since then it has traveled to two other galleries and was last exhibited in New York at my 1997 exhibition at the Wunderlich gallery. The painting, like so many others involving several figures, grew by stages. The first impulse to paint this picture came about when I saw myself reflected in the sliding doors of my summer studio. I guess I felt a little bit of vanity—I looked so healthy—which prompted me to make the drawing and from there the picture took off. But in the beginning it was purely vanity. The interesting thing is that the painting outgrew this immediate ego involvement and for that I'm grateful. The picture includes my whole family, and a variety of other visual explorations on the nature of "reality." (See "Sight and Insight," pps. 13 through 16.)

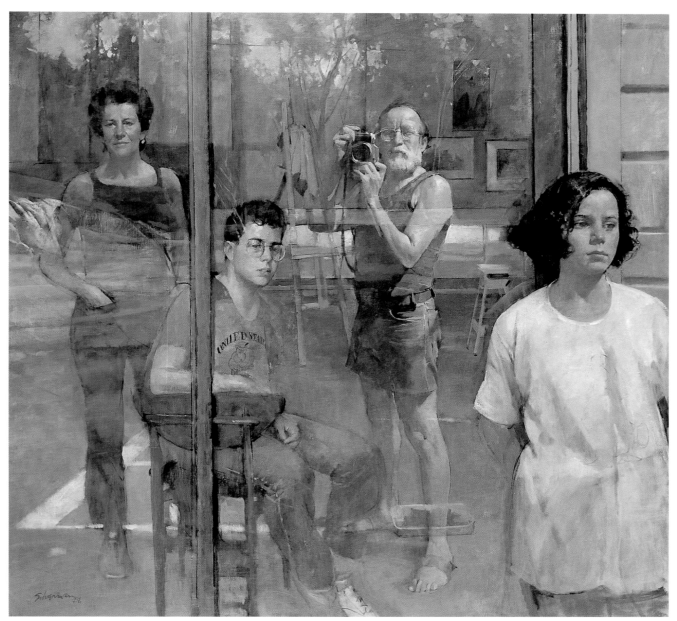

Plate 11. **Reflections**, 1987. Oil on linen, 52 x 48 inches. Collection of the artist.

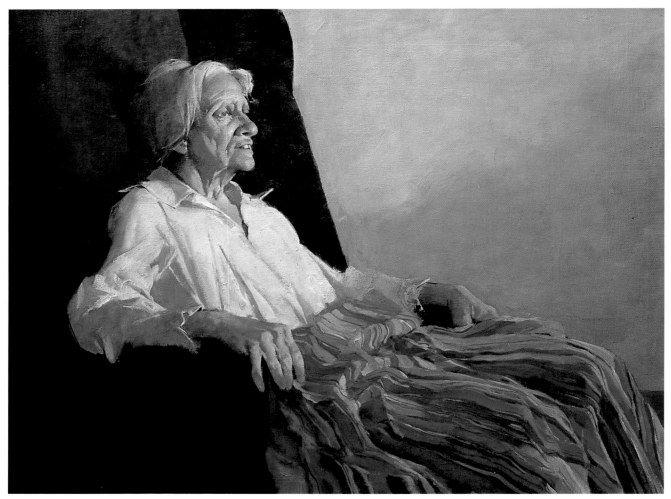

Plate 12. ***The 18th of May; My Mother***,1987. Oil on linen, 26 x 24 inches. Collection of the artist.

Plate 13. ***Study for The 18th of May; My Mother***,1978.
Charcoal, 24 x 28 inches. Collection of the artist.

After a year of hoped-for recovery from surgery for colon cancer, my mother began to succumb to the disease. I visited her daily. Ten days before her death, she drifted into another state, somewhere between life and death. As I sat there, unable to reach her, I became increasingly depressed and frustrated. I wanted to do something, to help her in some way. So I made several drawings of her on a telephone note pad, since I had not at all come prepared to draw. The drawings were my way of reaching her. The powerful memory of the light on her time-worn face, as she was dying, provoked my need to capture her image. The drawing (above) was copied from the small sketch on the telephone note pad. The painting wasn't made until two years after her death, as a final act of remembrance and a way to say goodbye.

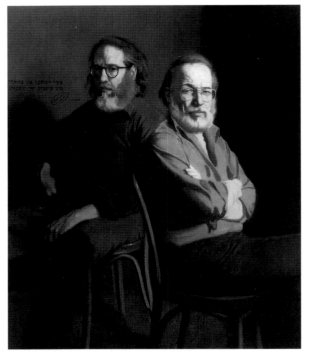

Plate 14a. ***Harvey Dinnerstein, Self Portrait with Burton Silverman***, 1987. Oil on linen, 38.5 x 31.5 inches. Collection of Mr. & Mrs. Robert Leggett.

Harvey Dinnerstein and I have been friends and colleagues stretching back to our student days at the High School of Music and Art in New York. Throughout our long history we have occasionally painted each other. This painting was the last of these mutual portrait sessions. Harvey's painting of me (left) became a double portrait, accompanied by an inscription in Yiddish, which translates as "Two Boys From Brooklyn." In my painting I decided to use the wall of paintings in my studio to add a self-portrait, thereby making it both a double portrait and a play on the artifice of painting itself. More importantly, I wanted to get both of us in the painting without destroying the compositional idea of a single standing figure. The drawing on the wall to the left of Harvey is one of the large studies I made before the painting was begun. I chose this pose because it echoed the Thomas Eakins portrait of *The Thinker*, and was thus a tribute to our mutual admiration of the great 19th century American artist. I also wanted to suggest similar qualities in my friend.

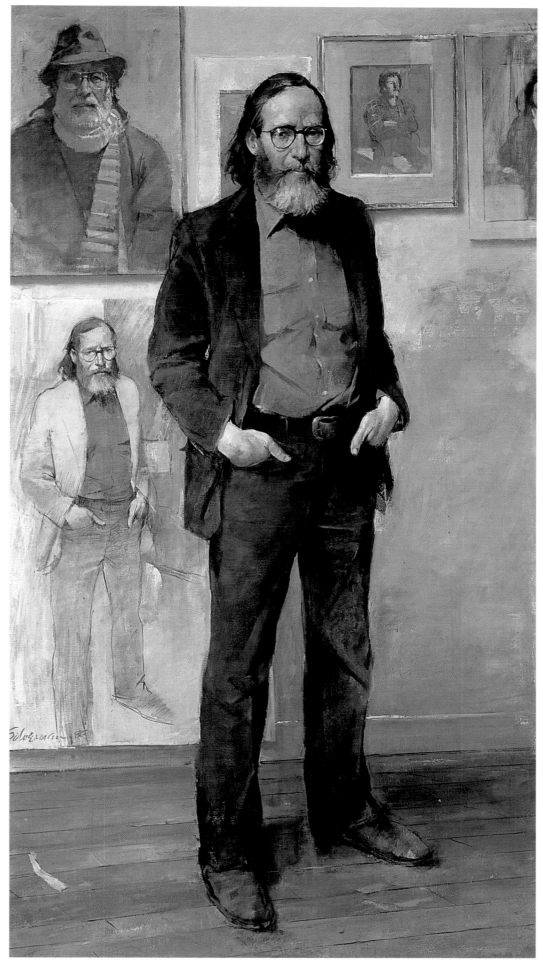

Plate 14. *Portrait of Harvey Dinnerstein*, 1988. Oil on linen, 42 x 60 inches. Private collection.

The bicycle riders who flourished all over Italy had a particular appeal for me. Maybe because I used to bicycle around Pietrasanta and to the beach every day. These Italians were daredevil racers, and were incredibly competitive. An annual race that was run in our town was terribly exciting because the course around Pietrasanta, first up the mountain directly behind the town and then down again, was tortuous and dangerous. The racers did not abide by any sense of honor—to win was the only goal. Older guys raced with 20-year-olds. I accosted one of the competitors and asked him to pose. He was too busy or nervous, but agreed to let me photograph him. I posed him this way, hunched over his bike, awaiting the start of the race. His face betrayed anxiety and doubt. In a review of this painting exhibited at the Sindin Galleries in 1983, Steven Heller would write: "At first glance, *The Rider*, a painting of a middle-aged Italian bicycle racer, frozen for an instant against a dramatically cracked wall, is a strikingly rendered and meticulously designed image. But it is also a uniquely revealing character study, which not only tells the story about this serious competitor but implies something more about Silverman's struggles; as well, perhaps, as an artist bucking the prevailing currents." I would do several other paintings of these same racers, years later, to try to elicit other aspects of the bikers and their passion to compete. (See Pages 74 and 75.)

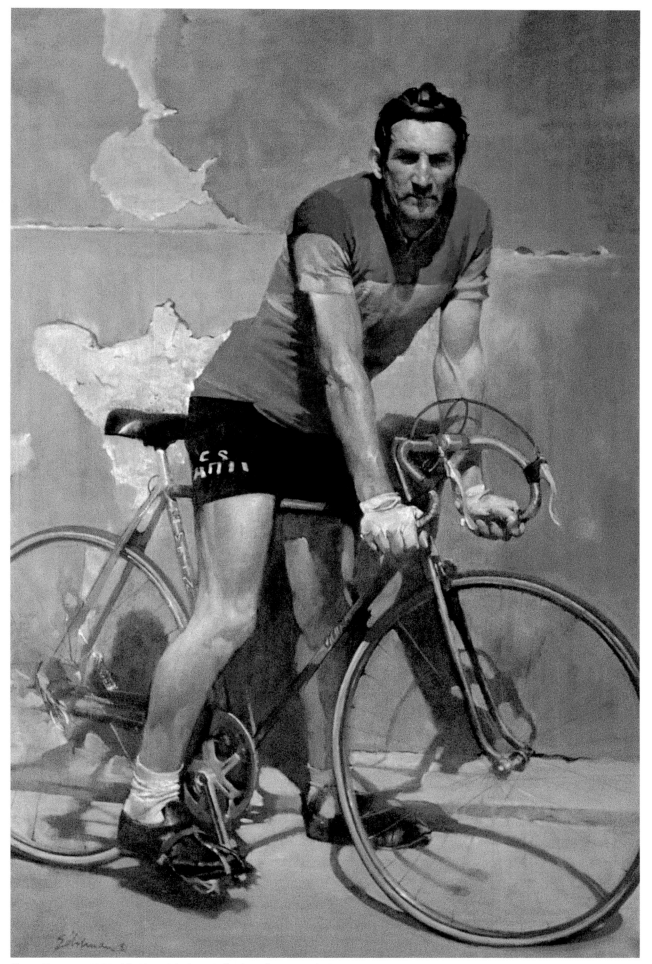

Plate 15. **Rider**, 1981. Oil, 60 x 42 inches. Collection of Stuart and Diane Brown.

Plate 16a. ***Study for the Big Red Machine***, 1981. Charcoal, 60 x 42 inches. From the artist's sketchbook.

This is a painting of Paul Lucchesi, the son of noted sculptor Bruno Lucchesi, whom I knew in New York and who also had a house in Pietrasanta in the 1970s. At the time, Paul was 18 or 19 years old and a free spirit much in tune with the young Italians in this small town and much a part of their *luftmensch* mentality.

I was attracted to their youthful ambiance and, perhaps, felt envious of their apparent romantic, care-free outlook (expressed by the unmuffled roar of the motorcycle). Paul, now an accomplished sculptor and teacher, agreed to pose with his red motorcycle in one of the narrow streets of Pietrasanta. The ever-constant sunlight was a tough problem—it is difficult to see color after a while in the sunlight—so as usual I made many sketches rather than try to paint in that difficult environment. The picture has sunlight in it, but it's not about sun; it's about youth and the power of the machine with its brilliant red color. I posed Paul both sitting on and supporting the weight of the cycle. It was something I did in order to give a slightly precarious feeling to the painting, despite the reposed cant of the boy's body. I think I felt the painting would otherwise be too pat, too matter-of-fact and too picturesque. Looking at it now I see it as an image of summer, of youth and of a time long ago.

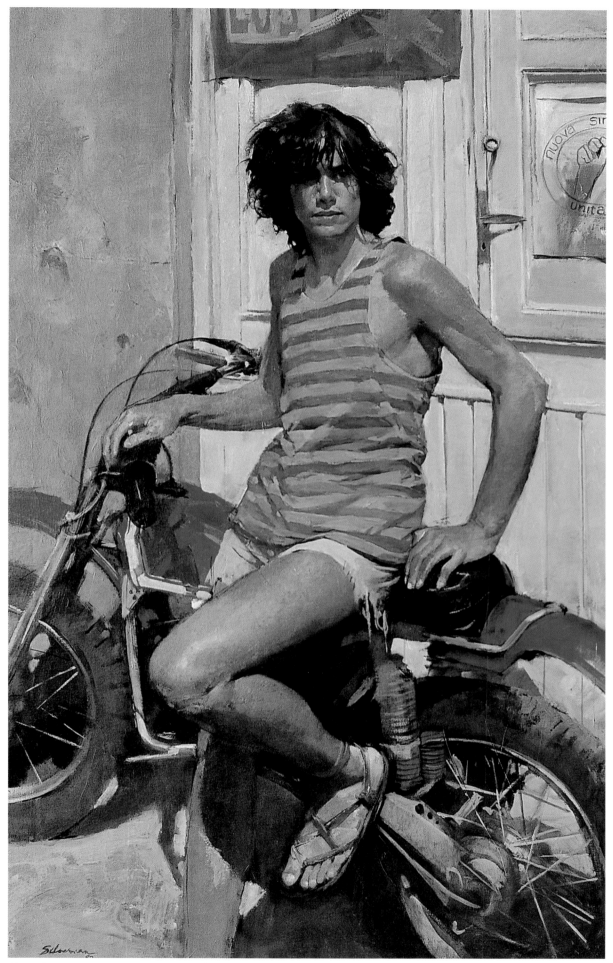

Plate 16. *The Big Red Machine*, 1982. Oil on linen, 50 x 36 inches. Private collection.

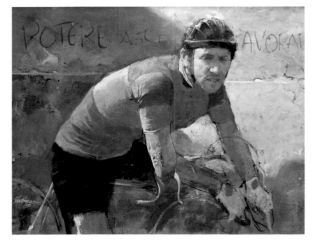

Plate 17. **Study for Power to the Workers**, 1996. Oil on panel, 16 x 20 inches. Private collection.

ower to the Workers was done fourteen years after the first *Rider*. (See Page 71.) I felt that some of the dramatic qualities that are a part of all sports were missing from the first painting. Once again I used the cracked wall behind the bikers to set off the bicyclists and the glittering color of their uniforms. But more importantly, I also wanted to concentrate on using the sunlight coming down the wall behind them as a device to spotlight the portrait of the lead biker, whose face expressed tension and, I thought, disturbance. His frown seemed to question the whole crazy race, and maybe all races. There was another element in the scene that I hesitated to use. The wall contained a graffito that read, in Italian, *"Potere agli lavorare"* (Power to the workers). I left it out because I thought it would be a little too poster-like. In retrospect, perhaps it was a mistake. The study (left) was an alternate image for the central figure in the painting and did include that graffito. The title *"Power to the Workers"* was a sly poke, I felt, at the Marxist fantasy about the working class.

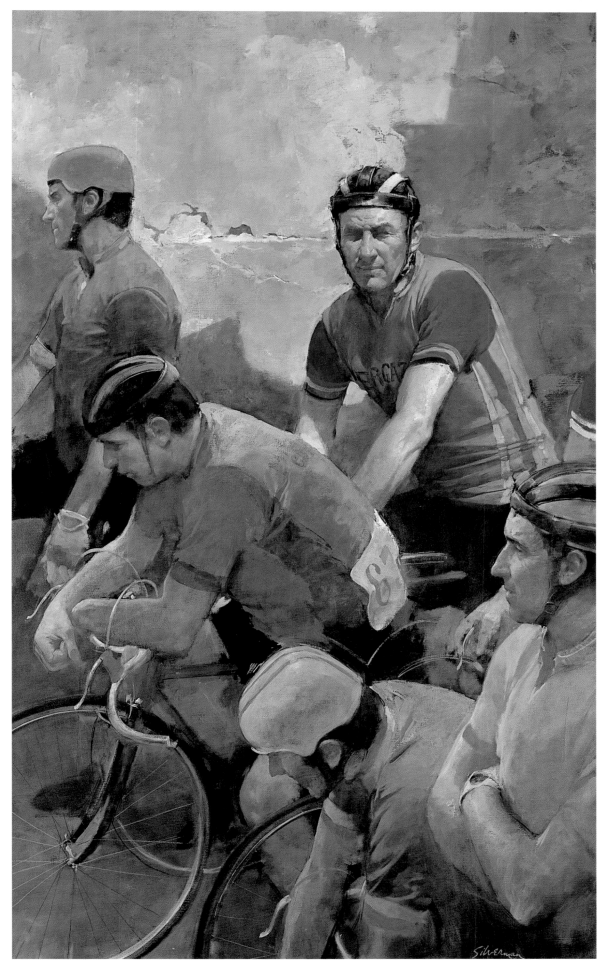

Plate 18. ***Power to the Workers***, 1995. Oil on linen, 58 x 36 inches. Collection of the artist.

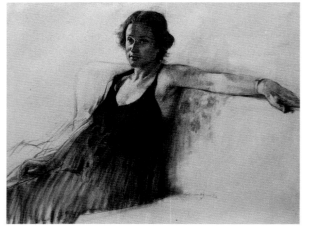

Plate 19. ***Study for Afternoon in Tuscany***, 1980. Charcoal and charcoal pencil. Collection of the artist. 1996.

This painting was originally intended to be a double portrait of a young couple that I had met at the wonderful Cafe Igea, where Americans in Pietrasanta usually gathered. The Sinclairs were one of the few American couples who were living in Italy the year round. Dan had decided that, to really learn to sculpt, he would have to apprentice to the marble carvers in town. He reasoned they would teach him the craft from the ground up. It turned out to be a grueling apprenticeship with long hours where he didn't touch a piece of marble for years. I found their easygoing equanimity in the face of this unusual "education of an artist" to be totally admirable and imponderable. We became close friends. Finally, Dan graduated and began to carve his own pieces. They managed to buy and remake an old Tuscan farmhouse, and Margo became pregnant. Dan is a gifted guitar and banjo player, and I wanted to paint them together with Dan playing for her. I had this image of a serenade to birth and renewal, a rather elegant and, I now think, mildly pretentious idea. It did not work out—the picture didn't feel right—and I decided to finish this painting of Margo pregnant and by herself. Thus, the content of the painting had changed significantly, and it became a portrait of a woman about to give birth and alone with her new future.

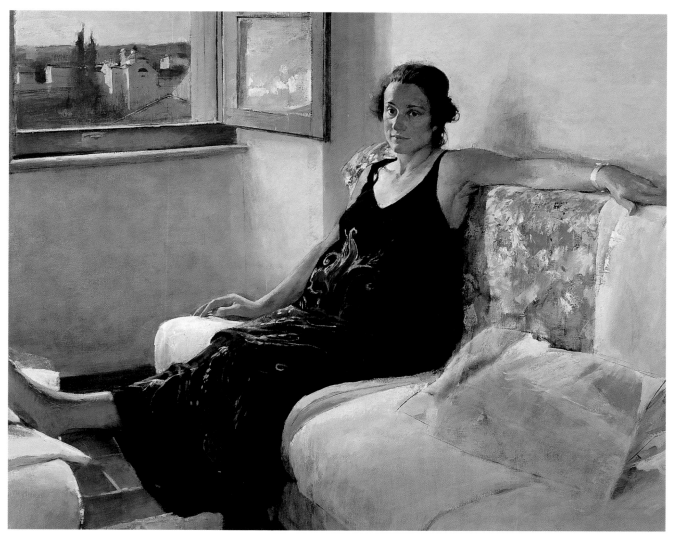

Plate 20. *Afternoon in Tuscany*, 1983. Oil on linen, 39 x 47 inches. Collection of Hal and Jesse Kant.

Plate 21. **Study for The Artisan**, 1980. Charcoal pencil, 18 x 14 inches. Collection of the artist.

Enzo is a master craftsman and one of the marble carvers-artigiani with whom Dan Sinclair apprenticed. (See Page 76.) I met Enzo several times and found him to be gentle and considerate and hardly the tyrant who bedeviled my new friend. I would also discover that his skill enabled him to copy virtually everything in marble, from Michelangelo's incredible *Pieta* to the most banal reliefs for the genteel English horse set. He wears the traditional marble carver's paper hat, which was made by folding the daily newspaper into a sort of crown-like cap to keep the insidious marble dust out of his hair.

I really loved doing this painting. Perhaps it is because it flowed so easily, or, then again, because of its light, high-keyed values. I silhouetted Enzo's head against the white marble reliefs, and this reversed the traditional light figure/dark background module found in a lot of realist art. I concentrated on the look in Enzo's eye; it was both sad and determined. I felt he was reflecting on the limitations of his job of merely copying other people's work. Maybe my presence as an artist spurred these thoughts. I'm only speculating here; perhaps this man merely stirred reflections about my own circumstances at that time that, as an illustrator, I was not able to fulfill all my aspirations. And perhaps, too, his cap was unsettling, like a fool's cap.

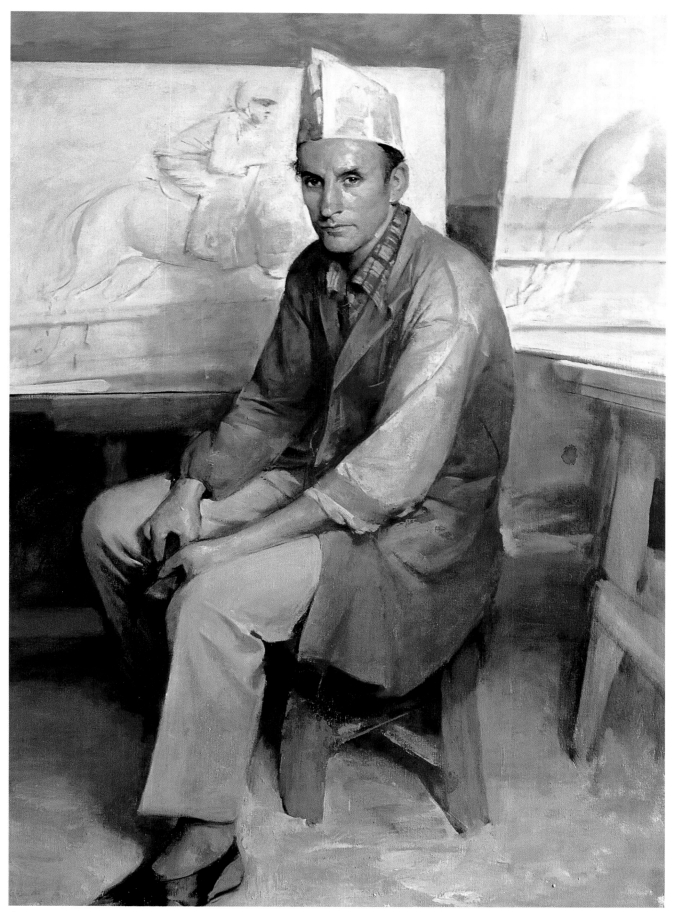

Plate 22. ***The Artisan, II***, 1998. Oil on linen, 36 x 28 inches. Collection of the artist.

After several summers in Italy, I learned enough Italian to be able to talk to people in the town of Pietrasanta. This permitted me to feel at ease in asking people to pose and also to understand a bit more about what they were like. This understanding has always been an important part of my art. Such was the case with this elderly woman who lived nearby. I would meet her every day and engage in small talk about the weather, about the scarcity of water in summer, about my kids. (They were the delight of all the neighbors.) Finally, after several summers had elapsed I asked her to pose. She agreed with an embarrassed shrug, and this painting evolved. I felt she was emblematic of all those women who had survived Italy's struggles—from the Renaissance to the Risorgimento, to Mussolini and the War. She seemed almost heroic. But she was quite human and in somewhat failing health. I posed her with the wine bottles because she gathered water from a little fountain down the street that supposedly had curative powers for all ailments, especially those for which the doctors were treating her. As with much Italian folklore, the legend failed to account for the fact that the same water also fed into the town's water system. I kept the barest hint of a triumphant smile on her earth-mother face.

Plate 23. ***Study for The Signora***, 1984. Charcoal, 16 x 12 inches. Collection of the artist.

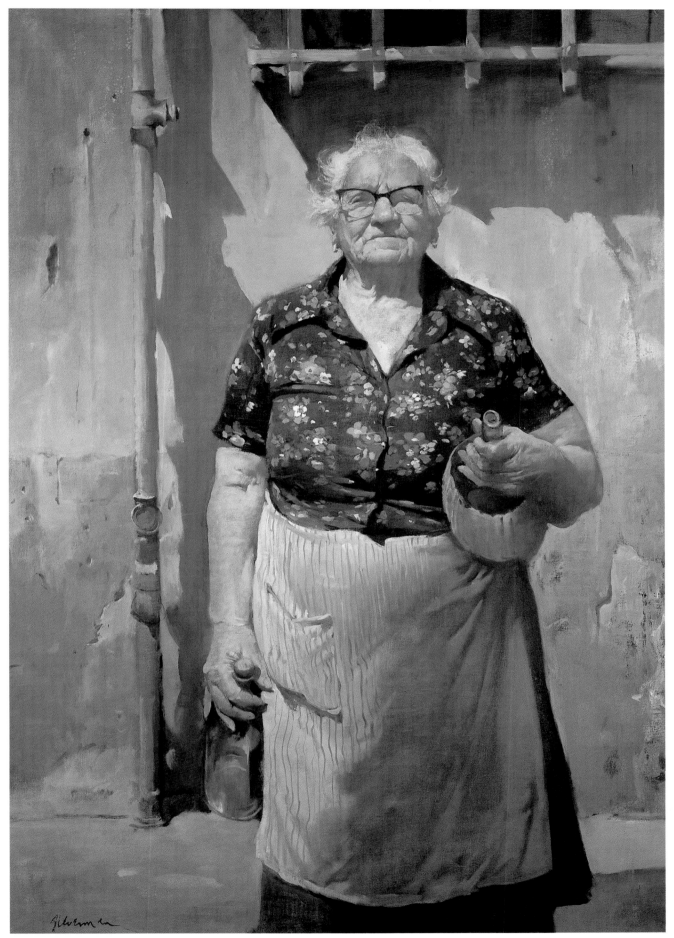

Plate 24. ***The Signora***, 1984. Oil on linen, 52 x 34 inches. Estate of Philip Desind.

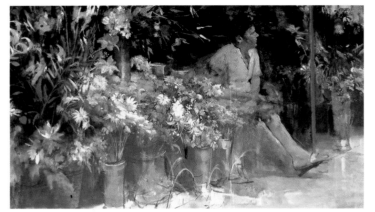

Plate 25a. ***Flower Market***, intermediate stage.

Italian cities and towns are sprinkled with flower markets throughout the summer season. This one attracted my attention because of the incredible array of colors and shapes and the often overly sweet aromas that resulted from it. I wasn't terribly interested in painting flowers—my aversion came from a rather dour temperament that doesn't care for "pretty" things. And this painting gave me a lot of trouble. It was started in the summer of 1979 on a canvas purchased in Italy that had a very rough surface. It was a large picture as well, and could be viewed from any distance only by opening the door of the small studio in which it was being painted and going halfway down the hallway leading to it. There I could see the picture with at least some perspective. But the painting kept eluding me, so I would remove it from the stretchers, take it back to New York, re-stretch it, and then leave it for months on end, waiting for a return to the flower market to refresh my vision. Also, the rendering of the flowers seemed impossible on the rough surface, and the central figure of the woman in the painting just did not have the right expression. (I tried putting two figures in the spot. It still didn't work.) It would go through many more such back-and-forth moves and significant changes before the painting would be finished. Finally, two-and-a-half years after the start in Italy, I did finish it. I felt triumphant. I think it was worth all that trouble because the painting continues to hold my interest. I think it's about this awesome profusion of flowers, which is almost self-canceling and was a hell of a challenge for me to paint. It is a sumptuous image but I also wanted the woman in the midst of it all to look somewhat bored and reflective. I think this was my statement, not only about what we call beautiful, but, possibly, a new take on the meaning of abundance.

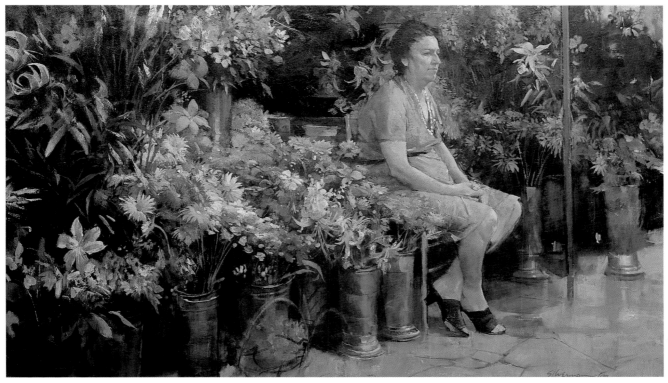

Plate 25. ***Flower Market***, 1986. Oil, 33 x 55 inches. Private collection.

Plate 26. ***The Machinist***, 1982. Charcoal, 24 x 14 inches. Collection of Claire Proffitt.

Behind the Scenes evolved from an assignment I had from a graphic design firm to make drawings backstage at the Metropolitan Opera in New York. For reasons I can't really explain, I have always been attracted to this kind of subject matter. But the simple thing is that I'm really stirred by the idea of people making things because that's what I do—make things. The detailed drawing of a man sewing backdrops (above) served as a model for the pose of the woman sewing in this picture. I did several other paintings involving the woman at the machine (see Page 33) because she seemed to me to epitomize, among other things, the postwar generation of women who continued to work after they had achieved a new-found independence in the labor market. In addition, she appeared to be like so many working people who do their jobs with a mixture of dogged acceptance and pride. She reminded me of my mother.

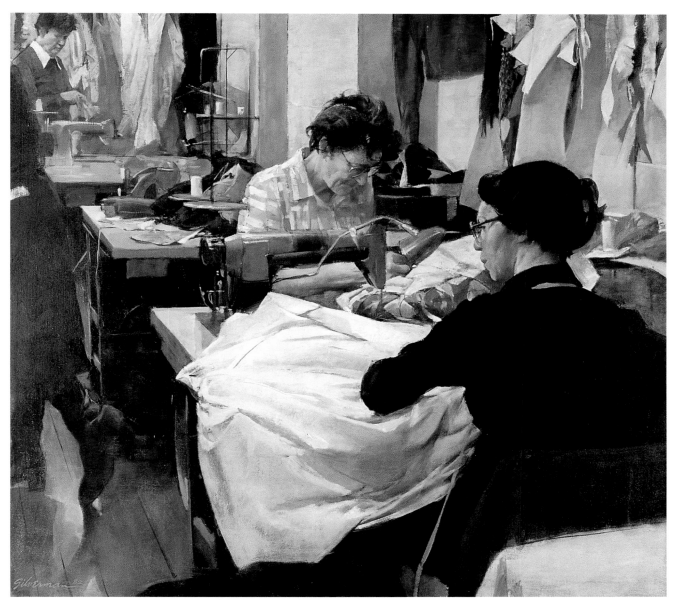

Plate 27. ***Behind the Scenes***, 1983. Oil, 32 x 46 inches. Private collection.

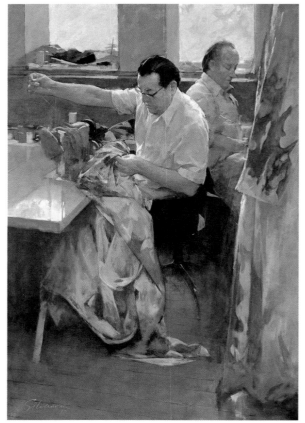

Plate 28. **Tailors**, 1990. Oil on linen, 55 x 38 inches. Private collection.

Costumes (right) is another of a series of paintings that I derived from my illustration commission at the Metropolitan Opera. The subject matter of this picture, as with others in the series, relates, in a way, to the period of the late 1880s when, spurred by Degas and the First Salon des Refuses, artists began to paint images drawn from everyday life. My intention was to record these unglamorous tailors and their mundane work in a straightforward manner without idealizing "work" or the "worker." I also liked the idea that men were pictured doing "women's work." The foreground costumes seemed to me like silent overseers and the faceless (female) costume dummies felt threatening. I think these paintings have an ominous presentment that is heightened by their very objectivity.

Plate 29. *Costumes*, 1990. Oil on linen, 30 x 24 inches. Collection of Dr. Howard and Ms. Roma Kaplan.

Plate 30. *A Woman Reading*, 1986. Oil on linen, 24 x 25 inches. Collection of James and Linda Spain.

Tracy is a portrait of a young woman whom I painted several times (Pages 91 and 94) and over a period of several months. She was pictured in different settings in those other paintings, but here I chose to paint a blank—paint alone—background. I wanted to focus on the very different look of a young woman with a steadfast gaze who is nevertheless cut off from contact by the gesture of her folded arms. But I also wanted to make the pattern of her hair and body an important part of the aesthetic of the picture. The painting *Woman Reading* (above) has a different feeling to it—a reflective one—but the intensity of the model's look was one I wanted to preserve. The title is inaccurate, for her book or magazine has been put aside and something about that prior activity now creates a thoughtfulness on her face. I painted her with her glasses on, behind which she both peers out and is partially hidden.

Plate 31. **Tracy**, 1990. Oil on linen, 32 x 24 inches. Collection of Mr. and Mrs. Mark Ratner.

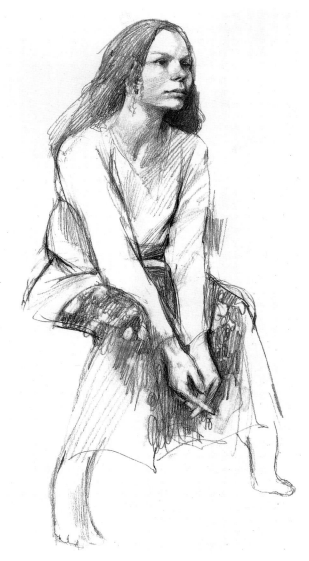

This is the same model, Tracy, who posed for several of my other paintings. I found her to be extraordinarily interesting, possibly because her look often seemed so hauntingly vulnerable. Other young women I've painted had similar qualities (See "On Women," Page 25), but Tracy was clearly the subject for some of the most affecting images. *Window Seat* shows her seated, almost crouched, on a bench in front of the windows of the studio. It was an intense pose that was not entirely my doing. I asked her to sit near the end of the bench and she just took that pose. The painting was exhibited at my second solo exhibition at the Capricorn Galleries in 1991.

Plate 32. ***Figure Study***, 1995. Pencil, 8 x 4 inches. Private collection.

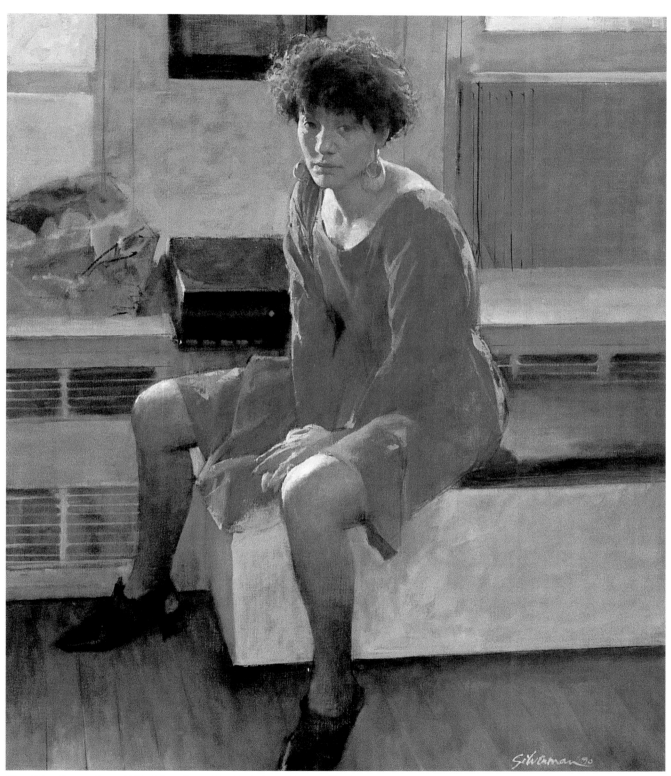

Plate 33. **Window Seat**, 1990. Oil on linen, 30 x 34 inches. Private collection.

Plate 34. ***Study for Trattoria***, 1984. charcoal on tinted paper,
18 x 14 inches. Collection of the artist.

I would often encounter this man in and around the coffee bars of Pietrasanta, where he would stop for a mid-morning cappuccino. The fellow's demeanor was always terribly restrained and he often dined alone. His suit and tie were always perfectly correct, which was almost out of place in a town where, during the summer and during the day, almost everyone was in jeans, shorts and sandals. The drawing shown here was done after I asked him to pose and while the restaurant was still fairly empty. I was to learn only much later that my subject was the former priest in the church and that a scandal forced him to relinquish his collar. Although he had lost his place and his honor, he stayed in town and became a courier and expediter of commercial transactions. Everyone treated him kindly and this, I think, is a tribute to this small town. But his fastidious manner and the way he dressed—with a defensive dignity—reflected the humiliation and terrible loss of social place that had occurred. The painting was done nine years later from the drawing.

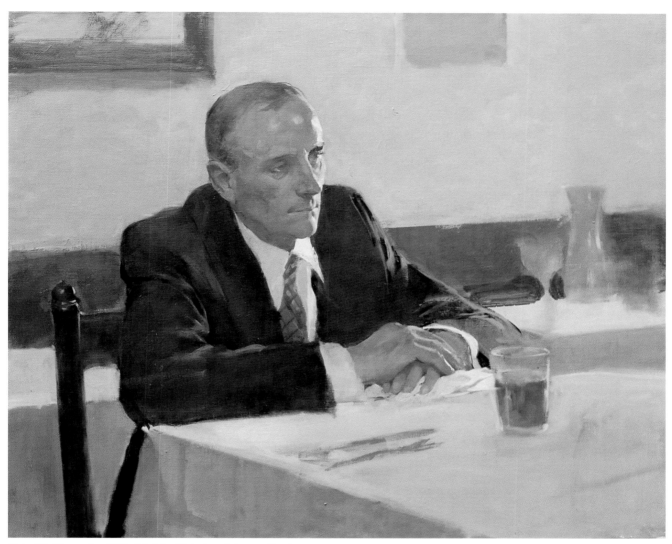

Plate 35. *Trattoria*, 1993. Oil, 24 x 30 inches. Private collection.

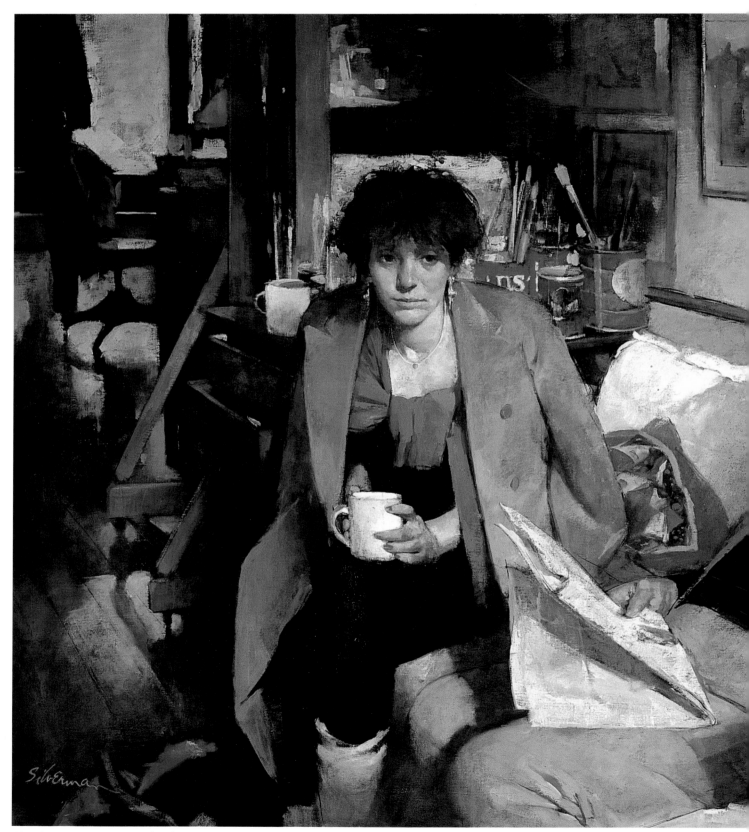

Plate 36. *Love Seat*, 1990. Oil on linen, 42 x 60 inches. Collection of Mr. and Mrs. Steven Cohn.

The couch pictured in the painting is called a *Love Seat*, but what happens in this painting has nothing to do with love. These two figures were taking a break from their pose for my class when I noticed them sitting this way. Something clicked. The two people were sitting together but were, nonetheless, worlds apart. Yet, by all accounts, they were friendly and talked earnestly together during the rest periods. What was the "truth" about these two? Did it matter? What came out of the painting, among other things, was a kind of ambiguity inherent in their brief relationship (as models) that spurred my interest in the first place. This painting was not difficult; in fact, it was often exhilarating because of the composition and the concept. It wasn't tough until it came to deciding on the final position of the man's arm. That sounds trivial, I know, but it was changed three or four times from resting flat on the sofa arm to being raised as you see it. I focused on that arm because somehow it seemed critical for establishing the emotional character of this man vis-à-vis the young woman. Another issue I found challenging, and then ultimately rewarding, was to establish the deep space in the background without losing the focus on the two people. It was exhibited at Capricorn Galleries in 1991 and the National Academy in 1992, where it was awarded the Joseph Isidor Medal.

The painting *Two Young Woman*, like many others, evolved out of the weekly studio classes that I've conducted for the last 27 years. The models were asked to come without any particular costumes, merely in their street clothes. What transpired took me by surprise; the way they posed together presented a psychologically curious interaction. The study (Fig. 16) and the finished large painting, I think, caught this mood. Was there a sexual connection here, or did I observe something that was merely the accident of the pose? In either case it worked to produce a picture that suggests something more complex but equally intangible. (See "On Women," Page 27.)

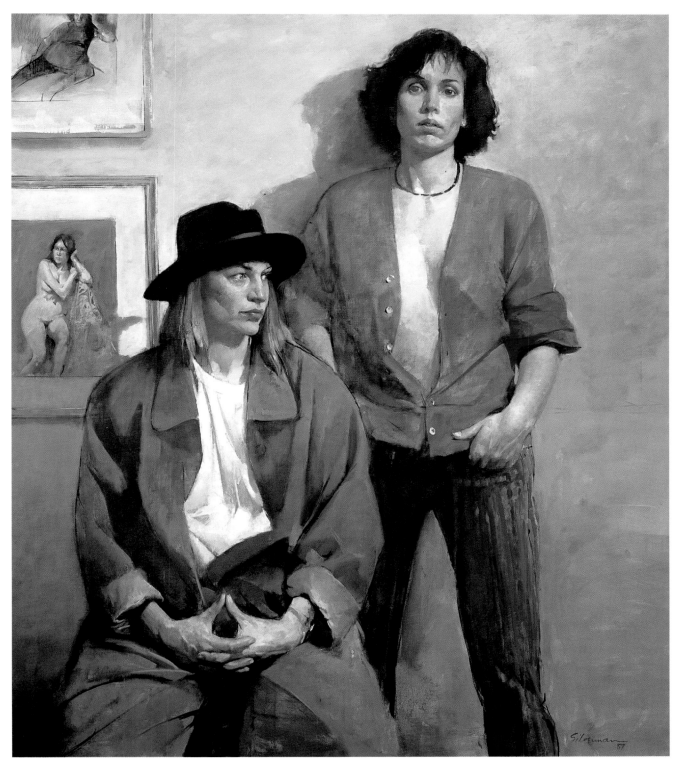

Plate 37. *Two Young Women*, 1989. Oil on linen, 45 x 32 inches. Collection of the Garchik Family Foundation.

Plate 38. *A Young Black Man*, 1987. Pencil, 8 x 4 inches. From the artist's sketchbook.

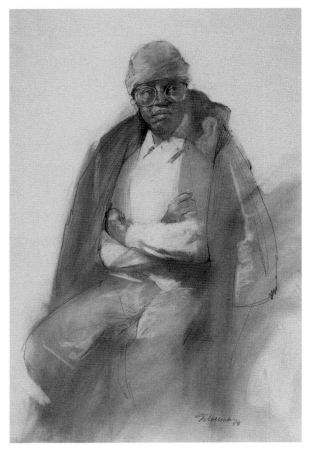

Plate 39. *Study for Jenay*, 1986. Pencil. From the artist's sketchbook.

This pastel, on a large format sheet of paper, was intended to be a direct and un-idealized treatment of this woman, whose weight seems more than a physical burden. But, inadvertently, I caught something else. Like a fleeting shadow, a pained or questioning look passed over her face. I have no idea what this might have signified, but I kept it there anyway. The pastel chalks were applied in broad sweeping strokes to give energy to an otherwise passive pose while the large scale of the pastel allowed me to render it with some freedom.

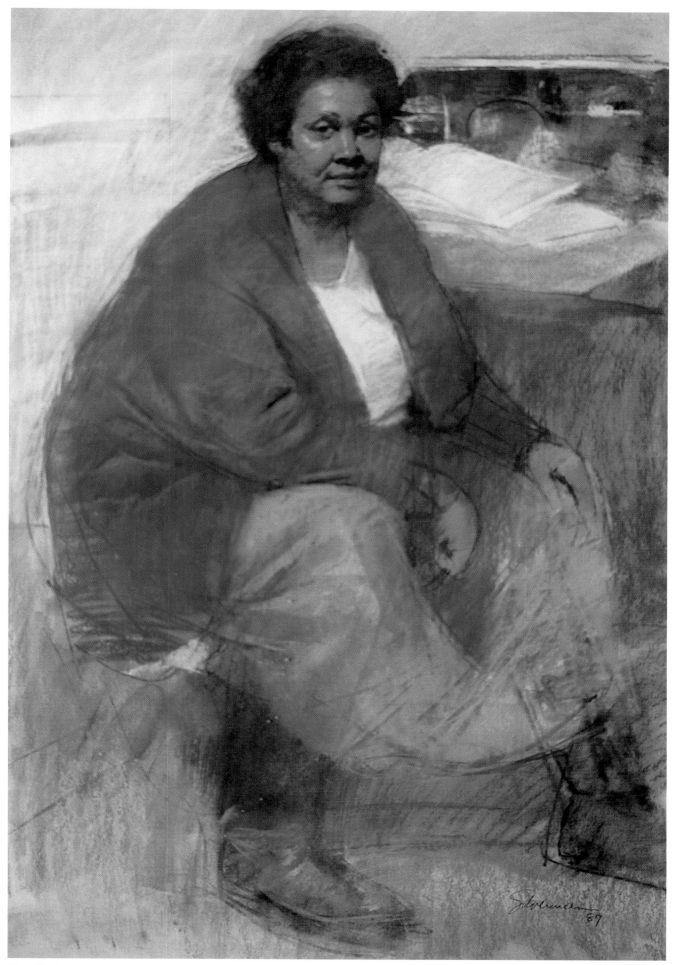

Plate 40. *A Black Woman*, 1987. Pastel, 42 x 28 inches. Collection of Helen and Hank Seiden.

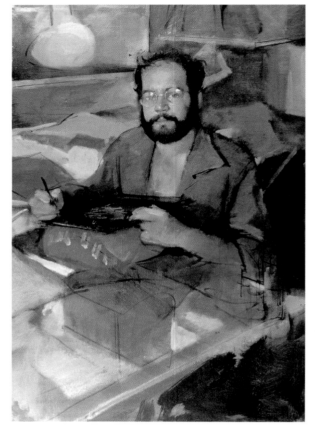

Plate 41. ***Study for The Etcher***, 1983. Oil, 20 x 14 inches. Private collection.

The summers in Italy in the 1970s became the source of much of my painting. For the most part I was too busy during the fall and winter months, with a growing number of illustration commissions, to develop subject matter closer to home. Initially, I visited this artist's studio in order to investigate his etching press. (I was doing monotypes at the time and needed a press to work on.) However, the idea of doing a painting of him presented itself as soon as I entered his studio. His affability and intensely lively look further enncouraged this impulse. His energy and vitality permeates this paining. I did the small study (left) to explore the compositional options for the final painting. I decided to make it a horizontal shape in order to use the wonderful clutter of his studio to create an interesting graphic design. Curiously, while the etcher was, in real life, extremely personable and gregarious, many of his prints were of faceless people, as can be seen in the etching in the lower left portion of this painting The first shows of my Italian paintings were at the Capricorn Galleries in Bethesda in 1979 and at the Sindin Gallery in New York in 1983.

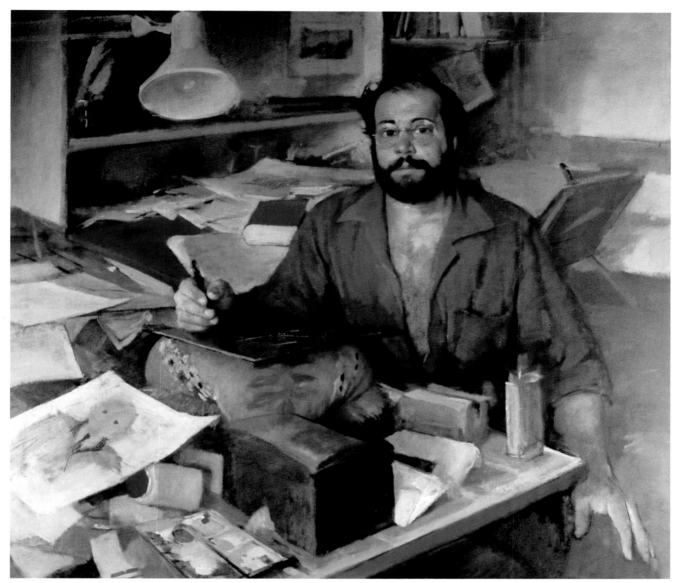

Plate 42. ***The Etcher***, 1983. Oil on linen, 30 x 36 inches. Collect ion of the Butler Institute of American Art.

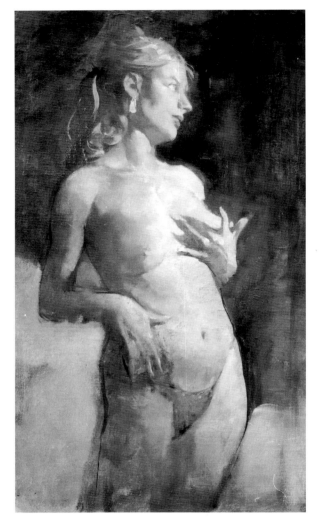

Plate 43. ***Burlesque***, 1985. Oil on wood, 21 x 14 inches.
Collection of the artist.

I came back to the theme of the strippers after a break of more than ten years. I'm not sure what prompted this return, although as I've written elsewhere, I had decided to make the portrait of the *Party Girl* central to these paintings so as to view her as an individual. In the painting of this young woman, so many different moods were part of her stance toward life that one painting was really not enough. Here I tried to express one of those moods. The contrast of the young woman's apprehensive look with her elegant and beautiful body was especially important for the realization of the painting. Interestingly though, in posing her, I had merely asked her to turn her head and look to her left. The look she has is either my distortion or a real expression of her feelings. In a vague way, this picture reminds me of Ingres' *Perseus and Andromeda*. However, my Andromeda has no one to rescue her. She is on her own, and only she can decide what will happen to her. But this is also misleading: Her real boss is the economic necessity that has ruled her life, and the realization that there is little chance of escape. (See "On Women," Page 29.)

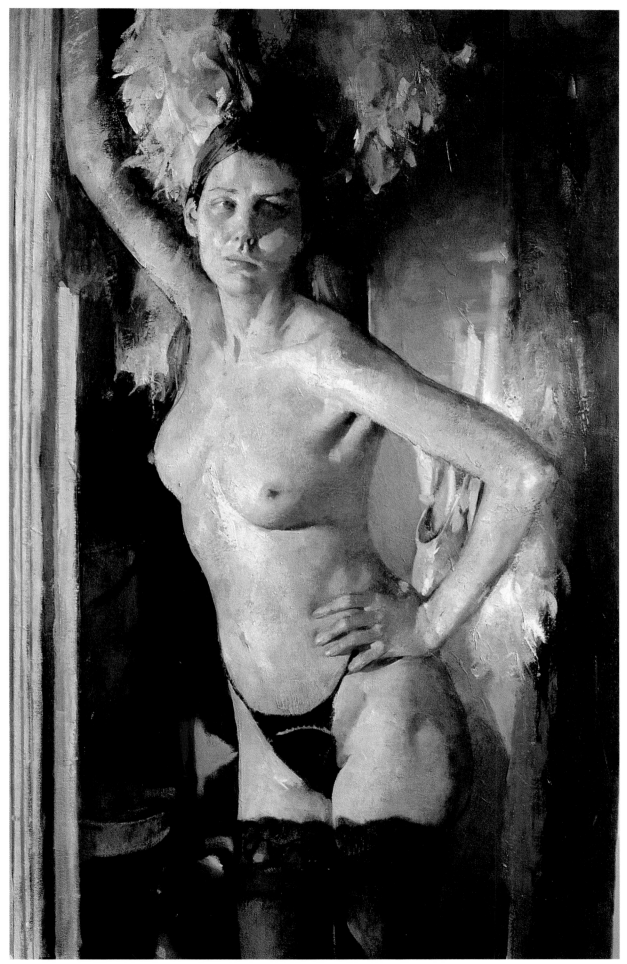

Plate 44. *A Dancer II*, 1996. Oil on linen, 36 x 26 inches. Collection of the artist.

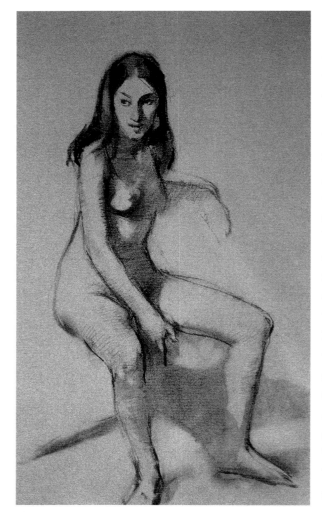

Plate 45a. *Seated Nude*, 1964. Charcoal, 14 x10 inches, Collection of the artist.

This was the last in a long series of paintings with the stripper/dancer as subject matter. The earliest paintings, dating back to 1976, were derived from the old burlesque houses, which still managed to survive in out-of-the-way places through the decade of the 70s. While these pictures were relatively benign—given the way sexual themes were presented at that time in many SoHo galleries, and with the art of newly emergent feminists—I still experienced some discomfort about the appropriateness of the material. I suspect I started to paint this theme again in the early 1990s because the whole tenor of public eroticism had changed to include strip bars, peep shows and late-night TV soft-core porn. I wanted to make a statement about the performer, rather than the performance. I think I also wanted to raise a voice on behalf of their human qualities without sentimentalizing them. I think the result, both alluring and disconcerting, justified my motives. The drawing shown here was one of many nude studies I made in the 1960s and whose pose curiously anticipates this late work. *I Am a Dancer* was exhibited at the National Academy Annual in New York in 1996 and at my solo show at Gerold Wunderlich in February 1966. (For more on this theme, see "On Women," Page 29.)

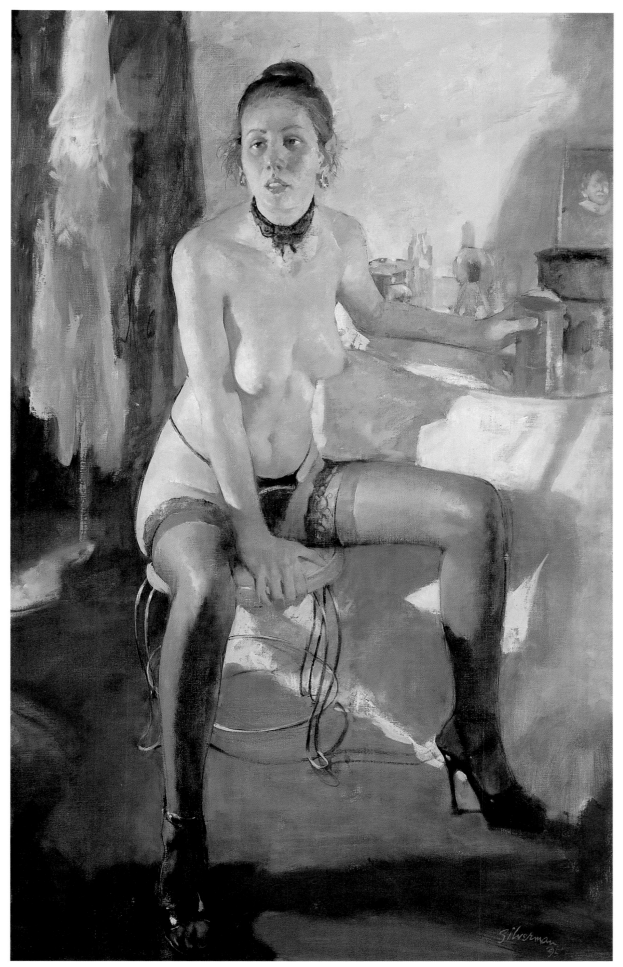

Plate 45. *I Am a Dancer*, 1996. Oil on linen, 50 x 32 inches. Collection of the artist.

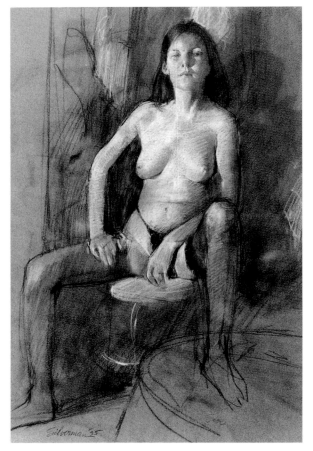

Plate 46a. ***Study for I Am a Dancer***, 1996. Charcoal, 18 x 12 inches. Collection of the artist.

The drawing of a "dancer" (left) was done ten years after the painting of the ballet student (*Seated Dancer*, right) and presents an interesting contrast in the two images, although both superficially have the same pose. What is different, of course, is the emotional stance of the two young women. The drawing was one of several studies I made in the small apartment occupied by the model. I felt this was a way to introduce a different, more realistic element in the picture instead of working in my studio. All the stuff around her became visually and narratively important. The result was unexpected. I think the young woman reacted negatively to my presence there because, although she was posing, she was also almost nude, and alone, with a man in her place. Her posture and her expression reflected this. In the *Seated Dancer*, the tutu validates the ballet dancer as a legitimate performer, as opposed to the "professional" stripper. But ironically her legitimacy is no guarantor of work. The painting was inspired in part by the color and luminous light of Eakins's *Lady With a Setter Dog*.

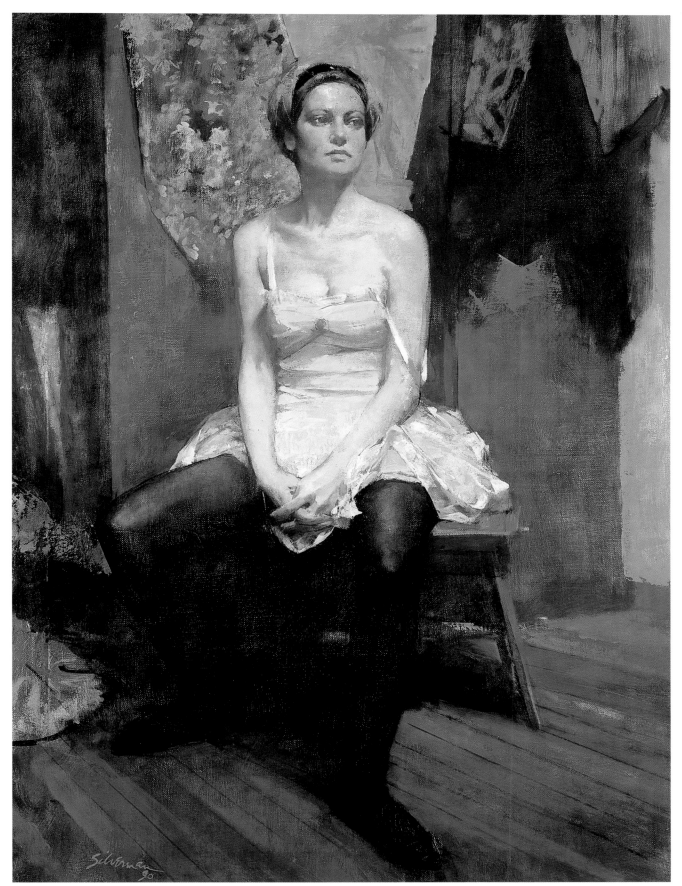

Plate 46. ***Seated Dancer***, 1990. Oil on linen, 30 x 24 inches. Collection of Roger and Marcia Simon.

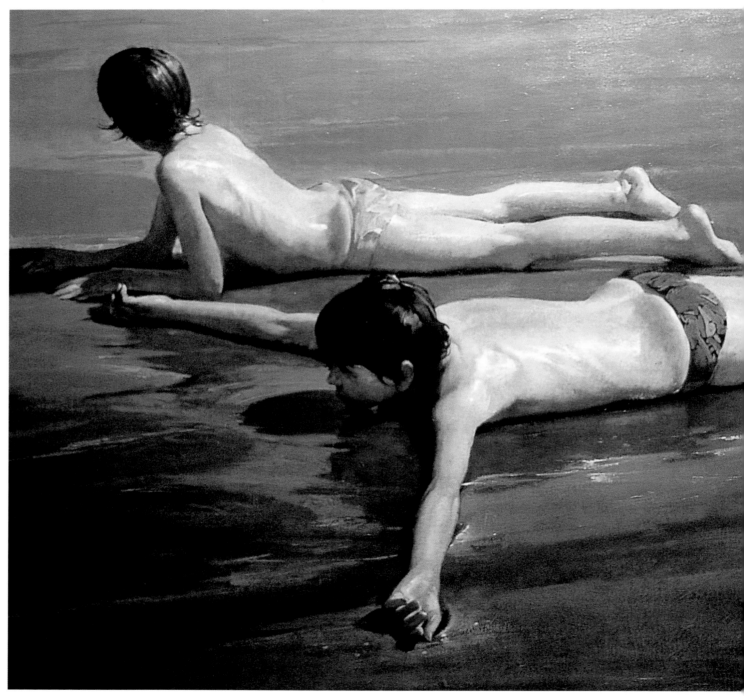

Plate 47. ***Low Tide***, 1982. Oil on linen, 60 x 42 inches. Collection of Ken and Shirley Johnson.

Of all the beach paintings I did in the 1980s, this painting remains the most centered around my own beach memories. As an adult I would often walk the shoreline, gaze out to sea, and then continue strolling again, watching people lying in the surf or just dozing in their beach chairs. And most often these people turned out to be kids raucously playing in the water or just sprawling flat out in the ripples of a gentle surf, lulled to reverie by the cool water. This was most likely my own fantasy, but the image of these two boys recalled those feelings. I did not exhibit this painting anywhere, because, unfortunately, it looked similar to some of the beach paintings of the 19th-century Spanish artist Joaquin Sorolla. I felt the reference would put my painting at an unfair disadvantage, because it would be read as indebted too much to the older artist. It's funny because, at the time, I felt that Sorolla's paintings were a little slim—all sunlight and wind-blown white outfits. I felt my kids in the surf were quite different from the sunlit, frolicking bodies in his work. And the mood in *Low Tide* is almost somber; the children are in their separate worlds, together, yet apart in their reveries. Somehow I feel this dreamlike painting recalls all childhood.

Plate 48. **Beach Figure**, 1974. Drawing from the artist's sketchbook, 5 x 7 inches.

In the first summers of our stay in Pietrasanta, I would draw constantly at the beach. At first it was a way to pass time on those long afternoons in the sun and, not incidentally, to satisfy my compulsive work habits. Later it became a catalogue of potential images to paint. The painting at right began with the sight of a woman seated on the sand in conversation with a friend. The sensuous curve of her back (she was not topless) was just amazing, and I thought it would make a marvelous form in a painting. Knowing the beach, however, I was afraid she would move, so I snapped off a few shots instead of trying to draw her. They turned out to be double exposures and almost useless. I reconstructed this pose in the studio, but as usual, before I was through, the painting had undergone many changes. I incorporated another figure of an older woman that was not part of the original scene. While the painting had been vaguely inspired by Titian's painting *Sacred and Profane Love*, which features a nude and a clothed woman side by side, it now had changed, as other feelings entered into the mix. (See "On Women," Page 26.)

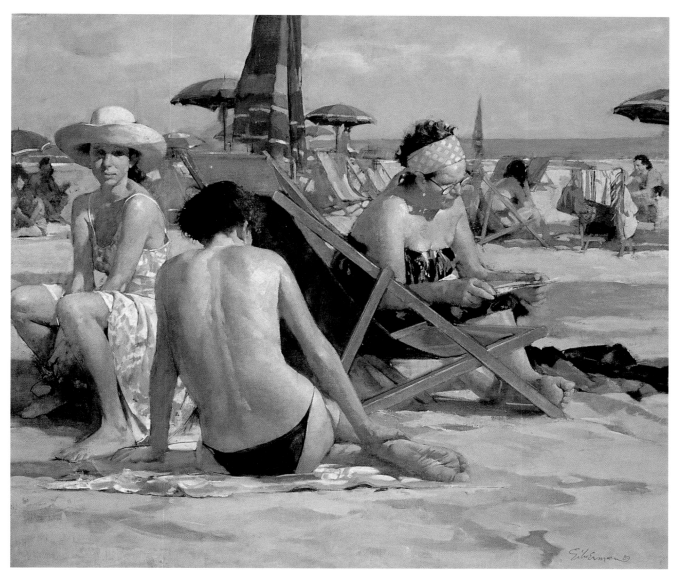

Plate 49. *Three Beach Figures*, 1990. Oil on linen, 41 x 48 inches. Collection of Patti and Jerry Sowalsky.

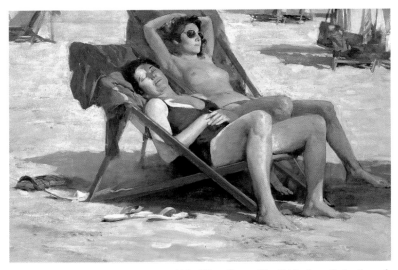

Plate 50. ***Dreaming of Fuseli II***, 1998. Oil on linen, 26 x 34 inches. Collection of Mr. Ed Gale.

We spent eight consecutive summers in Italy from 1972 to 1980. For the first three or four years, I did very little painting, but spent endless hours drawing at the beach and at the coffee bars in town, trying to figure out what I really wanted to paint. This would become clearer as I slowly began to make pictures—portraits really—of the working people of the town. (See Pages 30 and 32.) The woman in this picture, *Summer Sea*, is the same as in the painting *The Signora* (Plate 24), but by placing her on the beach, I intended to change her role from "Mama" to that of a more general participant in the life of the town. At the same time, she stands as a kind of icon of mother-hood, holding the social fabric together even though she seems isolated from the males (her progeny?) in the painting. These two figures were the original impetus for the picture. I wanted to paint them as "playing;" almost a throwback to childhood. From the vantage of pure painting enjoyment—and that does happen—the light on the back of the kneeling figure was very exciting. I particularly love the end-of-day light on the beach as a device to heighten three-dimensional form and for the nostalgic feelings it stirs in me. The paint-ing *Dreaming of Fuseli II* (above) is an example of reworking a prior painting of the same couple by adding the topless bather on the adjacent chair. (See "On Women," Page 26.)

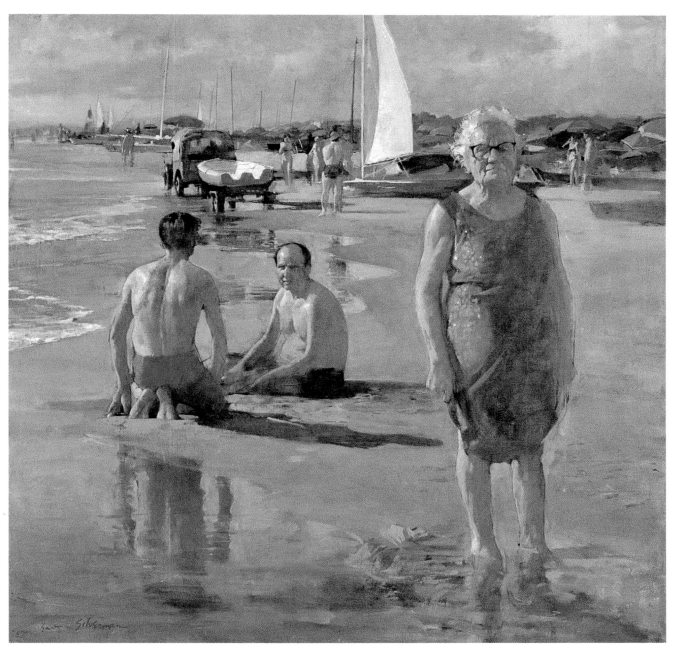

Plate 51. ***Summer Sea***, 1991. Oil on linen, 45 x 32. Collection of Mr. and Mrs. Edward Peskowitz.

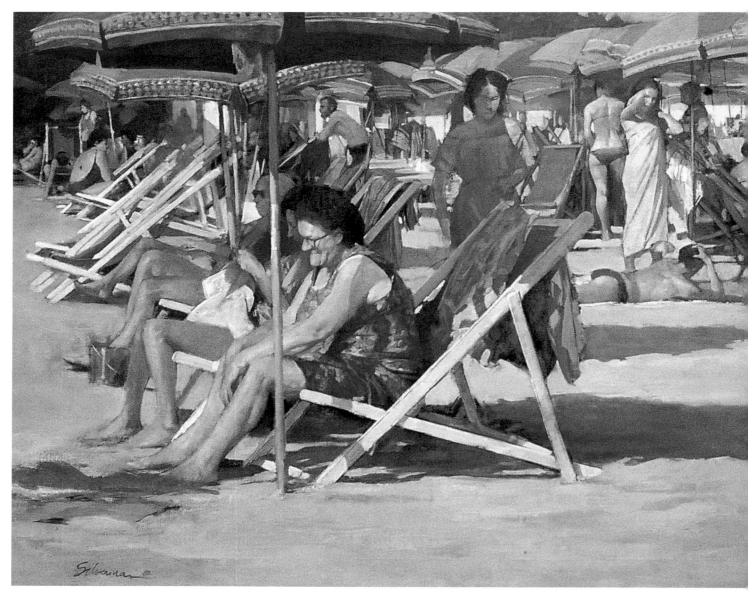

Plate 52. *Passage to the Sea*, 1978. Oil on linen, 30 x 53 inches. Private collection.

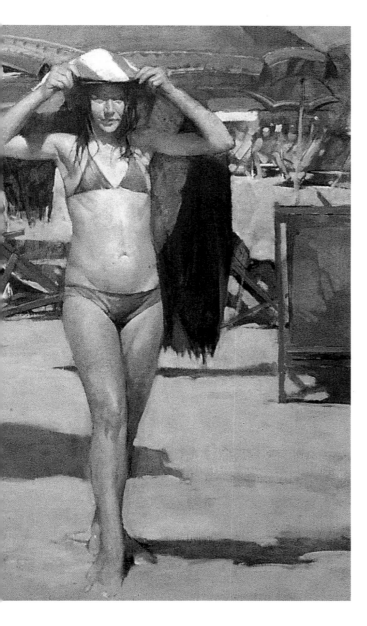

The beach became my studio, with people taking different poses and in different combinations wherever I looked. And it was further enlivened by the visual qualities that came from the array of multicolored beach umbrellas, the crisscrossed patterns of the beach chairs and the multicolored towels slung over their backs. The pageant of moving bodies or people curled in the chairs was a constant invitation to draw and a constant challenge to my skills. Everything moved and shifted almost constantly and frustratingly. Eventually I resorted to photography to get it all. I thought *Passage to the Sea* would be a summary statement of all the prior beach paintings as well as a metaphor for the maturation of a young girl (on the right), with her eyes looking seaward, squinting into the sun. Her passage was also made more strained by the implicit pull of the mother figure sitting resignedly in her chair, which I felt had universal qualities: assenting to the break with her child but only barely. This painting is also interesting to me because it represents a break from the tight spatial platforms I normally used, including the deep perspective, which carries the eye back and then forward again, and mimics the constantly moving bodies strewn along the way.

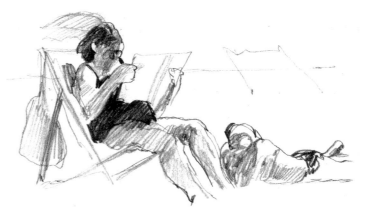

Plate 53. ***Woman in a Beach Chair***. Pencil, 4 x 5 inches. From the artist's sketchbook.

Plate 54. **Beach Chair**, 1998. Oil, 30 x 24 inches. Collection of Mara and Steve Appel.

This picture finally did summarize more than a dozen oils and watercolors I painted on the beach theme. It would not have been possible without a significant change that came to the beaches through the spread of topless bathing, which came from the spas of the French Riviera and slowly made its way down the Italian peninsula. Although youth and age coexisted on these beaches for years (and was something I had tracked in earlier images), it was now put into sharper focus by the bare-breasted women. In *Two Women*, however, my topless bather is not particularly physically arousing, nor is her pose. In fact, the opposite seems more accurate—there is an intense thoughtfulness about her, as if she were growing aware of the brevity of her youthfulness. The painting uses warm colors, but they are not naturalistic. Some are really much closer to flesh colors that would be found in the studio light where, in fact, the young woman was painted. *Beach Chair* (left) is another version of the topless figure that I considered for this painting.

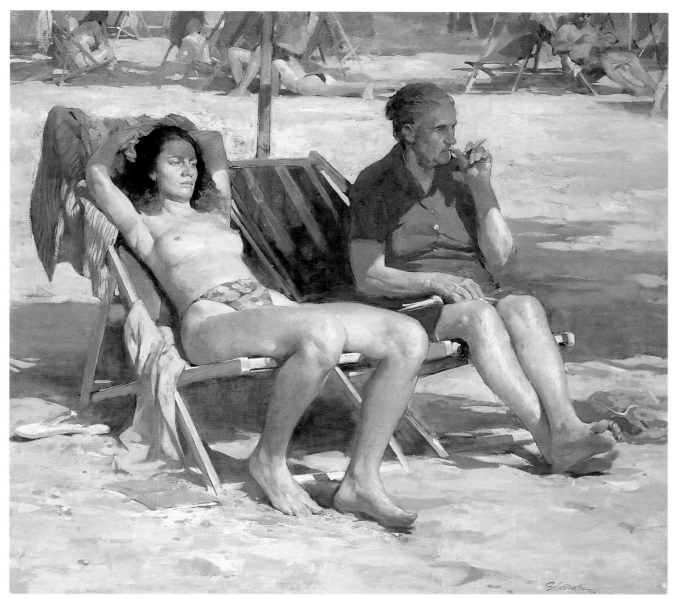

Plate 55. ***Two Women***, 1994. Oil on linen, 32 x 54 inches. Collection of Seymour and Judy Wagner.

Plate 56. ***Pond at Sunset***, 1997. Oil, 20 x 24 inches. Private collection.

My country studio is located in the lush landscape of the lower Hudson Valley of New York. While I've loved it as an escape hatch from city hassles, I only got around to painting it quite recently. I was wandering around the pond on the property when I looked up and saw the sun disappearing behind a stand of trees. It was a hazy late afternoon in August. The mood of the picture was engendered by the last rays of the sun and the waning summer days. It's what the painting is about. The landscape was the stage set for these feelings. I did four or five versions of this scene, some with a view higher up on the hillside over-looking the pond (above), and all of them suffused with a Romantic nostalgia. The large painting, *Evening Over Hidden Brook*, was the last of this series.

Plate 57. *Evening Over Hidden Brook Pond*, 1996. Oil on linen, 35 x 50 inches. Collection of Mr. Wes Porter.

The Taconic Parkway became another source of landscape for me. I have this inexplicable affection for these rocks that line the roadway. Certainly, compared with the magnificent rock formations to be found out West, these are rather paltry little stones. But I love that they are small and accessible. The faceted, sculptural surfaces of the rocks and the way their color changes with different light, different seasons and different times of the day make them marvelous to paint. I also feel these rocks form a silent sculptural reminder of our earthly environment that has been "wounded" by the road, by civilization. At least this is my poor way of trying to describe what may, in fact, be their fascination for me. In this painting I focused on the lonely rock, isolated and spotlighted in the sea of green, looking stranded and forsaken. The picture is painted thinly except for the rocks, gleaming with impasto whites, in the shadow of the overhanging trees.

Plate 58. *Taconic Series; Near Pudding Street*, 1997. Oil on linen, 20 x 28 inches. Collection of the artist.

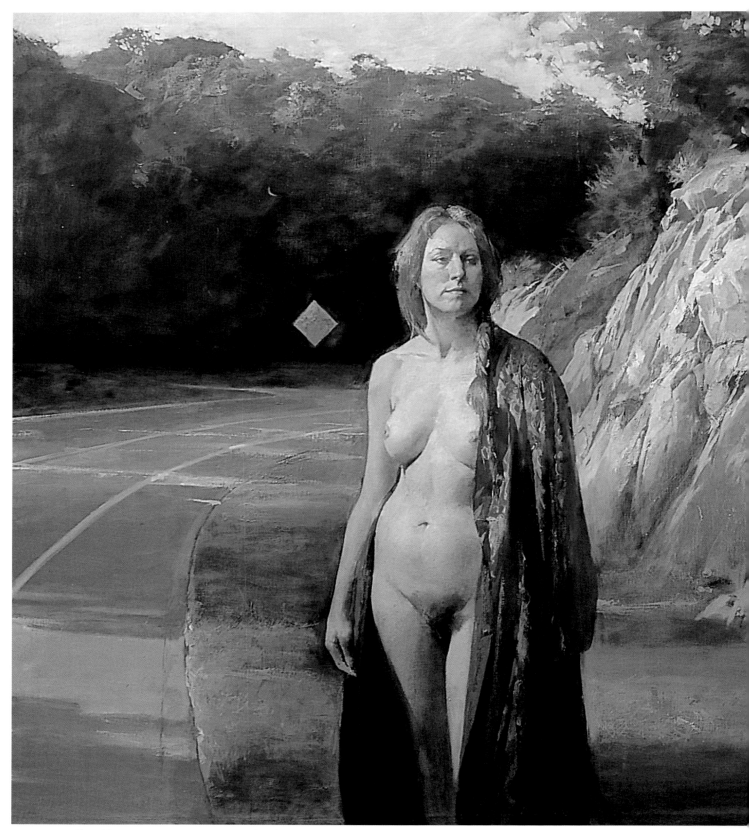

Plate 59. **T-Junction; Rte 52**, 1997. Oil on linen, 45 x 60 inches. Courtesy Merrill Gallery.

Plate 60. Taconic Series, Bull Head Road, 1997. Oil on wood, 12 x 20 inches. Collection of the artist.

My interest in the rocky landscape abutting the highways leading to my summer studio (*Taconic Series; Bull Head Road*, above) inspired me to start a large canvas of this subject. Halfway through the picture, I began to have doubts about its viability. It seemed dull and lacked the sense of wonderment that motivated the other paintings of this theme. Having just painted a nude outdoors, I thought, partly on a whim and perhaps intuitively, I would paint a nude into this scene. Hiring the same model who had posed for *Nude Outdoors* (Page 125), I lit the figure with an incandescent spot and simulated the late afternoon sunlight that was part of the original landscape. The result was something rather unexpected and, it happens, controversial. (See "On Women," Page 30.)

Painting a traditional female nude was something I had abandoned in favor of the more challenging themes of the sex trade. The model who had posed for my summer workshop changed my mind. Her face had a strong, almost Gallic quality that made her body seem even more classic. I had had some vague notions about painting a nude outdoors, which was not a brand-new idea, I grant. There were loads of precedents for this, starting in the Renaissance and ending, perhaps, with Manet, Anders Zorn and the other late 19th century painters. But once outdoors, the changes in feeling were noticeable. The darkened woods behind the model seemed more ominous and the raking light, late in the day, seemed to intensify her tentative stance. All of this was capped by the look of concern on her face. That look, I discovered in subsequent conversation, was the feeling she had of being simultaneously fearful and sensually aroused. She wasn't sure what had brought about these sensations.

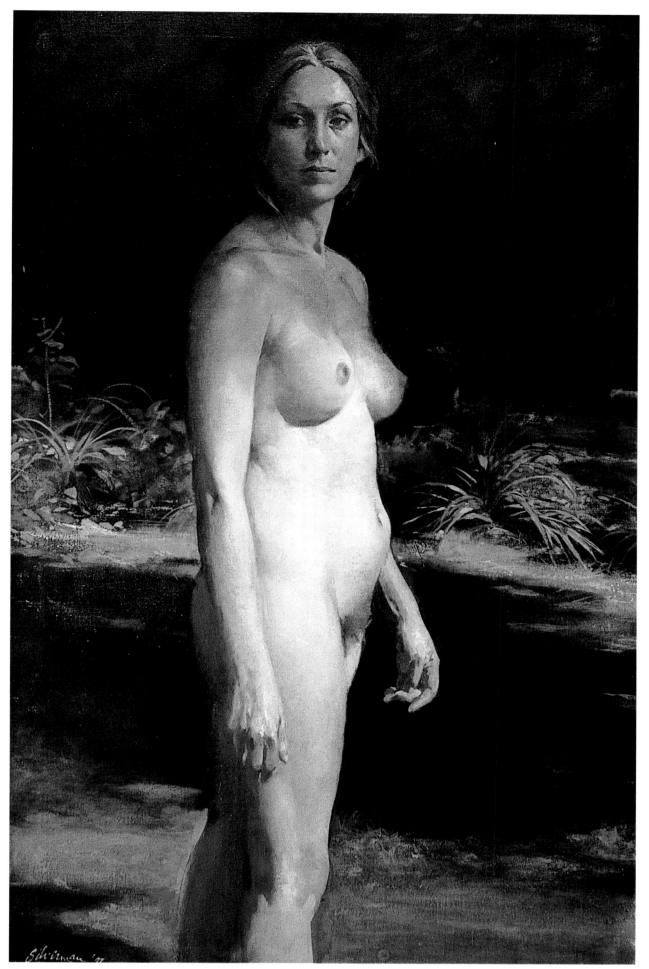

Plate 61. **Nude Outdoors**, 1997. Oil on linen, 36 x 24 inches. Collection of the artist.

The series of paintings done on this theme relied heavily on the camera. What transpires after the photo is back in the studio, however, is an attempt to see the photo as if it were, in fact, the real thing. This requires repeated efforts to parallel the responses and the vitality that accompanies direct, real-world contact with the subject.

The storefront depicted here is just a block from my studio, and I pass it almost daily on my errands—going to the bank, to the film store, to the supermarket. The life of the city seems encapsulated in these glass-enclosed eateries, and somehow they become imbued with an importance that I cannot always fathom. This older woman became a paradigm of the elderly people in my neighborhood who carry a lot of life's baggage etched in their faces. *Lunch Date* was my way of acknowledging their gifts of survival. It was also a way to acknowledge my affection for them. The photo was a poor substitute for the reality of the scene; I struggled to make it come alive.

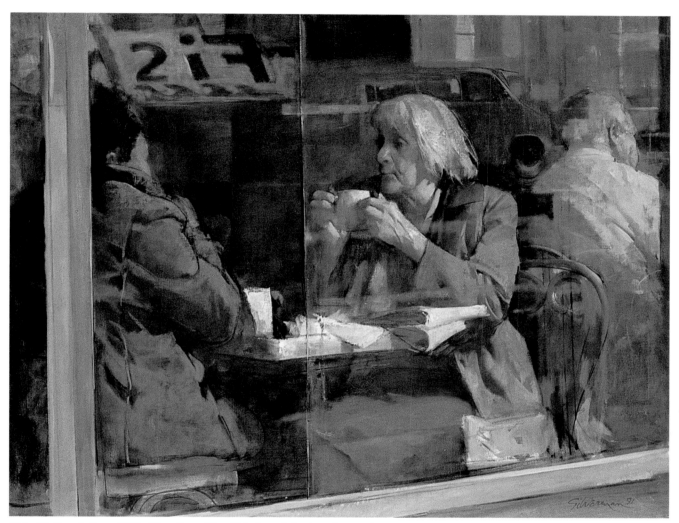

Plate 62. **Lunch Date**, 1992. Oil on linen, 30 x 39 inches. Collection of Dr. and Mrs. Seymour Hepner.

I, along with the members of my weekly class, would eat at this cafeteria on a regular basis. The setting became the subject of several paintings, all titled *Pier 72*, the establishment's name. I appropriated the place as my own and turned it into a kind of studio where I often drew people eating and eventually posed a couple of my students to model for this painting. (For a full discussion of this painting, see "Sight and Insight," Page 20.)

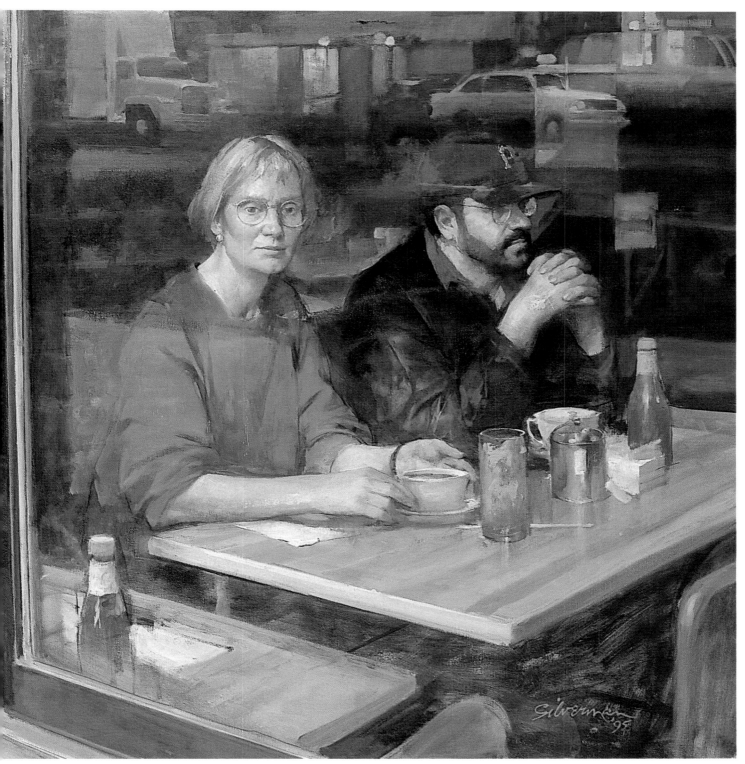

Plate 63. ***Pier 72; The Information Age***, 1995. Oil on linen, 35 x 51 inches. Collection of the artist.

Plate 64. **Waiting to Be Served**, 1996. Oil on linen, 22 x 34 inches. Collection of Frances and Irving Phillips.

In the painting, *Bagel Nosh*, I was not interested in the restaurant except as an arena in which people were physically close yet separated by their own preoccupation. The title of the painting is the name of an indoor/outdoor glass-enclosed "boite" (literally "box") on the Upper West Side of Manhattan. "Nosh" is a Yiddish word meaning a snack, usually one that implies unhealthy, continuous nibbling at food. I'm a constant stroller in my neighborhood on the Upper West Side, and passing this food place, and others like it, I'm suddenly aware of the strange sensation of being an inadvertent voyeur. Perhaps this was also the experience of others who passed these glass-enclosed places. I was somewhat frustrated by the flat lighting and the profiled portraits as presented in the photos I

took. These are limiting factors for me, since I find it hard to access personality and character this way. Nevertheless, I felt intrigued by the gesture of the woman, the central figure in the painting. The fact that it was ambiguous—meaning, I'm not sure what it was— struck me as just right for this combination of figures. She made it work. The painting *Waiting to Be Served* (above) used a similar setting and my good friend, Irv Phillips, as the model. The content of this painting, however, is different. The isolated image of this man, whose dignity masks other, more problematic concerns, is nevertheless one of quiet and courageous endurance. I only wished that the light was different, more dramatic. But perhaps this very lack of "drama" makes the painting more effective in the long run.

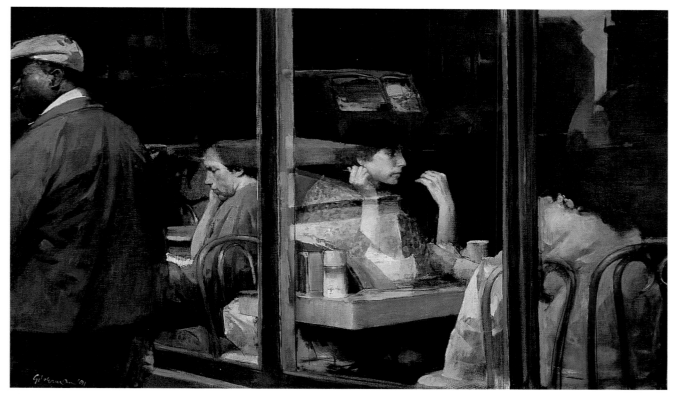

Plate 65. ***Bagel Nosh***, 1986. Oil on linen, 52 x 30 inches. Collection of Dr. and Mrs. Monroe Pray.

Plate 66. ***Arch Deluxe***, 1996-97. Oil on linen, 32 x 48 inches. Collection of the artist.

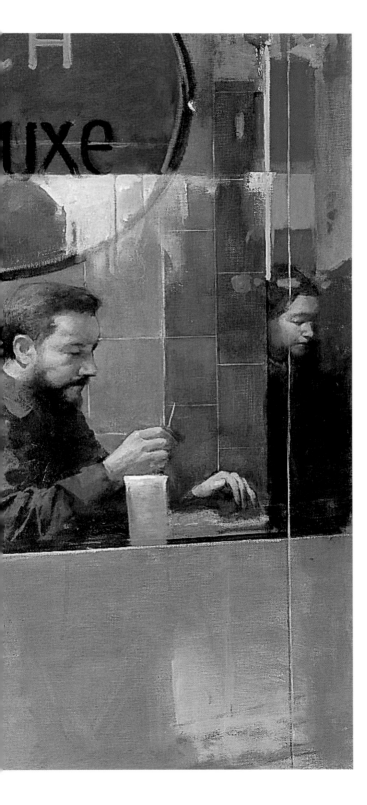

Arch Deluxe is a kind of triumph. It has nothing to do with the possible merit of the painting; it's just because I was really challenged to get the image right, and I think I did. I was particularly riveted to the figure of the man in the leather jacket. Somehow he seemed to be right out of a 1930s movie: slightly down-and-out, no family, and with a menial job. This is probably all subjective fantasy, but it motivated the completion of the picture. I worked on his head almost every time I worked on the rest of the painting, scraping it out many times, because somehow it missed that absolutely dead-on characterization that was so important to its success. The painting also presented compositional problems, and I altered the size of the image and the canvas itself several times. (See "Sight and Insight," Page 18.)

Plate 67. **Study for Woman Seated in a Wicker Chair**, 1995.
Pencil, 9 1/2 x 6 inches. Private collection.

The model for this painting, *Woman in a Wicker Chair*, had posed in my summer workshop at my country studio. She was just in her early twenties but she seemed older because of her demeanor, which was gravely serious. I was intrigued by the utter clarity of her features in contrast to the frequent, tense looks she evinced. And the graphic quality I wanted for this painting was the combination of the dark hat and the pale coloring of her face and neck. The drawing was the beginning of the search for these qualities. It also revealed the first hint of that frightened look that turned up in the final picture. The painting is as much about the play of light and its visual impact as it is about the character of the young woman.

Plate 68. ***Woman Seated in a Wicker Chair***, 1996. Oil, 30 x 24 inches. Courtesy Merrill Gallery.

This portrait, of an unknown young model who posed for me many years ago, still has many qualities that satisfy me. The sculptural sense of her head, combined with a look that seems apprehensive and yet composed, is an element I did not consciously pursue but that is often part of my paintings. An interesting sidebar to this picture occurred several years back. I had painted simulations of other pictures hanging on the wall to the left and behind her head. Every time I looked at photos of *The Green Scarf*, I kept seeing those pictures on the wall. At last I worked up enough courage to call the collector, and told him of my discontent and that I wanted to paint out those pictures. It was a meeting of minds because he, too, had wanted to call and ask if I was completely happy with the painting the way it was. I changed it to a simple paint background and both of us were much happier.

Plate 69. ***The Green Scarf***, 1984. Oil on canvas, 30 x 2 inches. Private collection.

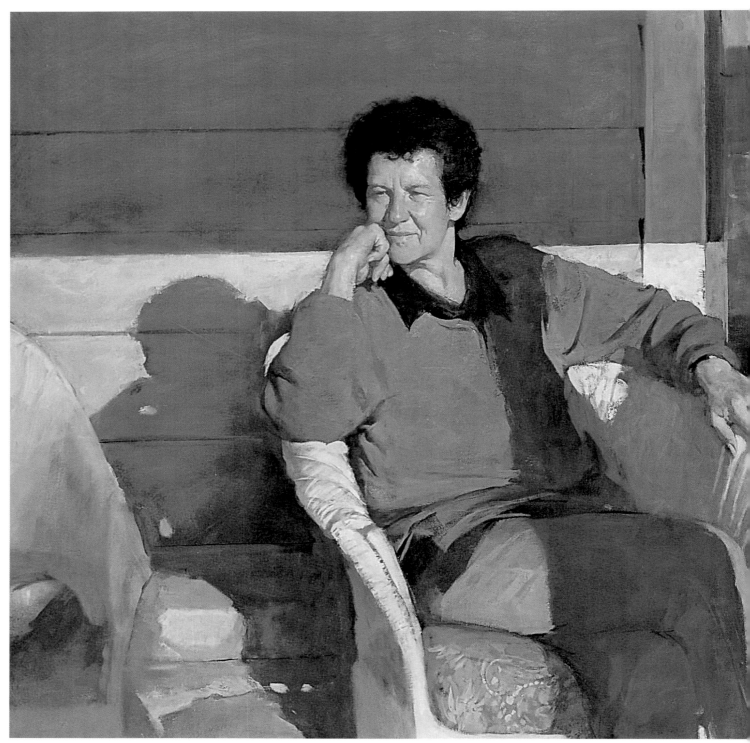

Plate 70. ***October Light***, 1995. Oil on linen, 34 x 51 inches. Collection of the artist.

138

This painting is set on the porch of our summer residence. I've discovered all kinds of possibilities both for painting outdoors and for using the exterior architecture as a background for figure pieces. It also has challenged me to paint the sunlight, something that troubled me a bit, even in Italy, since paintings in this mode can often turn out to be somewhat frivolous. The dramatic late afternoon light slanting into my wife's eyes made the pose difficult to hold. I decided it was going to have to be done mostly from photos. Because the sun was moving so fast, I photographed the image at slightly different times in the afternoon and with the sunlight at different angles in order to approximate the way I would have seen the figure if I were painting it live. I think it did turn out acceptably. I also liked its relatively large scale, which permits one to experience the light and color more intensely.

A constant feature of the New York subways, over the last fifteen years, at least, has been the itinerant musician. He or she has played, singly or in groups, every kind of music and with every kind of instrument. The environment is a challenge for any performer, with trains making a roar that drowns out any sound and acoustics that would daunt even rappers. This woman is dressed in the kind of neutral outfit reserved for unisex haircut parlors. She was disarmingly forceful in her singing and quite good. But the audience was not there. I thought of her as a paradigm for all artists who struggle to perform under the most difficult circumstances and who are often isolated from society. I photographed her as I was coming down the steps of the subway. The painting was an attempt to capture the feeling of loneliness hanging in the air, mingling with the rhythmic beat of the guitar strings.

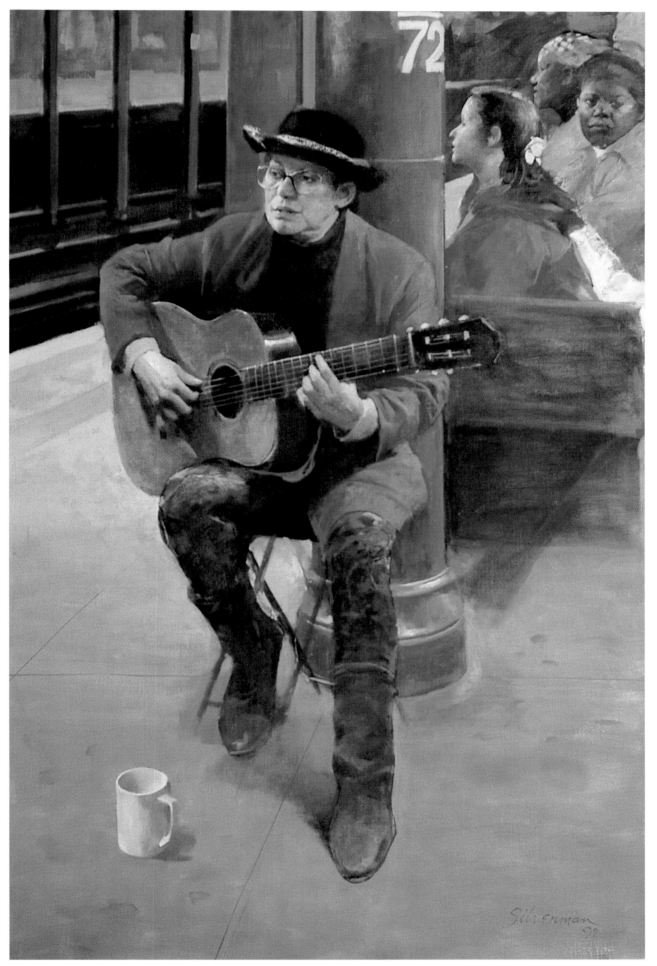

Plate 71. *Subway Song*, 1997. Oil on linen, 52 x 36 inches. Courtesy Merrill Gallery.

Herb Steinberg, another of the members of the "Realist View" exhibition and a longtime friend from high school days, was a talented artist whose professional life barely got started. Raising a family early in his life, he was forced to take work as a scenic artist, painting scenery for Broadway shows. But because he was an artist underneath it all, he continued to paint his own pictures throughout the long years in which his devotion to family overcame his heartfelt ambitions to be a painter. Herb would, after long absences, visit me to spend several hours in my studio, talking about art and just catching up on things. We respected one another. On one occasion, which would turn out to be the last time I saw him, I drew him in the late afternoon light, smoking his perpetual cigarette. Eventually that became the painting reproduced here. As I look at the painting after many years, I can see once more Herb's warmth and constancy. Sadly, the cigarette in his hand was almost surely the cause of his sudden and premature death from a heart attack. The worst of it was that, at long last, his career as a painter was just beginning to happen. The painting was finished after his death. A retrospective of Herb's work was held at the Capricorn Galleries in Bethesda in 1990, and a portion of his remaining work has been donated to his alma mater, Kent State University.

Plate 72. *Portrait of Herb Steinberg*, 1990. Oil on linen, 30 x 24 inches. Collection of Louis and Sonia Rothschild.

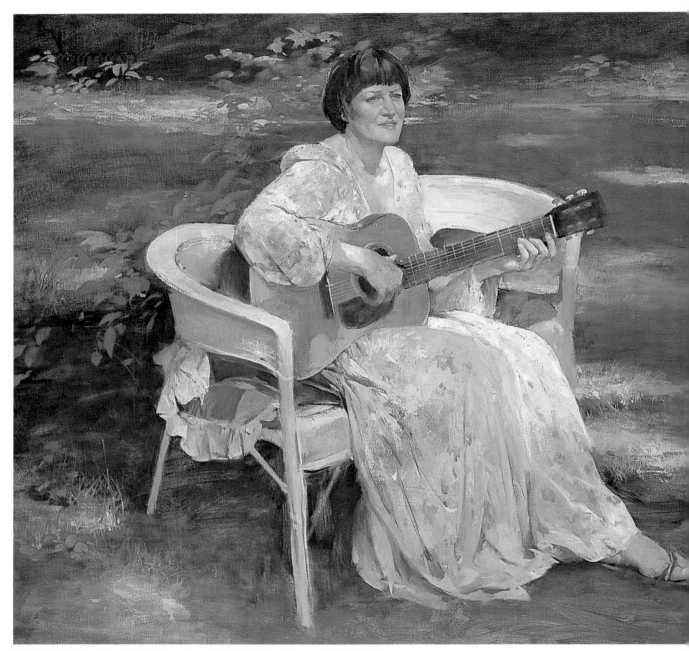

Plate 73. *Celebration*, 1996. Oil on linen, 38 x 48 inches. Courtesy Merrill Gallery.

I had done several paintings in this setting (see *Nude Outdoors*, Plate 61) and found it to be a serene little oasis from the hot summer sun. I believe the memory of childhood events can account for a great many things we are drawn to as adults. Perhaps my affection for the country stemmed from my summer vacations in Spring Valley, New York, when I was 7 or 8 and when the newness of country and sun made such a strong impression on my senses. In this painting I especially enjoyed suggesting the feeling of the cool air and the trickle of sunlight over the green grass. I confess to having enjoyed the painting because it came into being so easily. There was no anguish or sweat about it. I think that's why it seems a little like cheating. This model, who came to pose for my summer workshop, was a musician and provided a musical complement to this dream-laden, grassy spot. I did several studies of her and then this painting, which had no other point to make beyond its sheer pleasantness. Even the old-fashioned dress has a nostalgia about it, and I think that is the real content of the picture.

Summers in Italy we would often go on Sunday picnics, packing kids, food and blankets—very Italian-style—into a car no bigger than a small dining room table. We'd go to many different spots, all of them physically beautiful, but of no interest to our children. This was one of them. I took pictures, as I always did, dutifully. Years later, I saw them and was struck by the almost dreamlike quality of the event. Many things interested me: the people all going in different directions, Fellini-like, and the feeling of being free and on top of the world. It was a compelling image. Curiously, I wanted to paint that cut grass without actually painting one blade of grass. I did this by scumbling, glazing and scumbling globs of paint, over and over again, with my palette knife. In the end, I actually did have to paint some of the blades. It was a different experience and a different kind of painting emerged.

Plate 74. *Picnic*, 1997. Oil on linen, 32 x 50 inches. Collection of the artist.

Our house in Italy was being cared for when we were away by our neighbor, Signora Bacci. Over the years we developed a close relationship with her that grew to be quite emotional at times. It seemed that we always arrived in summer to warm greetings, kisses and tears, and left with wringing of hands, sorrowful looks and more tears from our dear Signora. Over the ten years or so that we were in Pietrasanta, we saw each other's children grow up, and exchanged stories about them whenever she came to the house to clean. During those times I steadfastly tried both to keep painting and to keep my language skills afloat. Her daughter had grown to be a strikingly handsome young woman, and I asked to paint her. She agreed. As I painted her in the small kitchen of their modest little house, something quite unexpected began to unfold. Her expression began to grow more intense and almost seemed to border on fright. I believe I learned why. Signora Bacci announced one day soon thereafter that her daughter was engaged to be married, an announcement that was also accompanied by tears. At that point I suddenly understood the intense look of her daughter when she was posing. The painting, called *Corner of the Kitchen*, is the portrait that emerged from this poignant tale. I guess I intuitively felt something about the girl, Giovanna was her name, and her newly achieved status that caused me to place her in a cramped space, walled in by the table and chair. She was, after all, her mother's daughter, and this was probably her destiny.

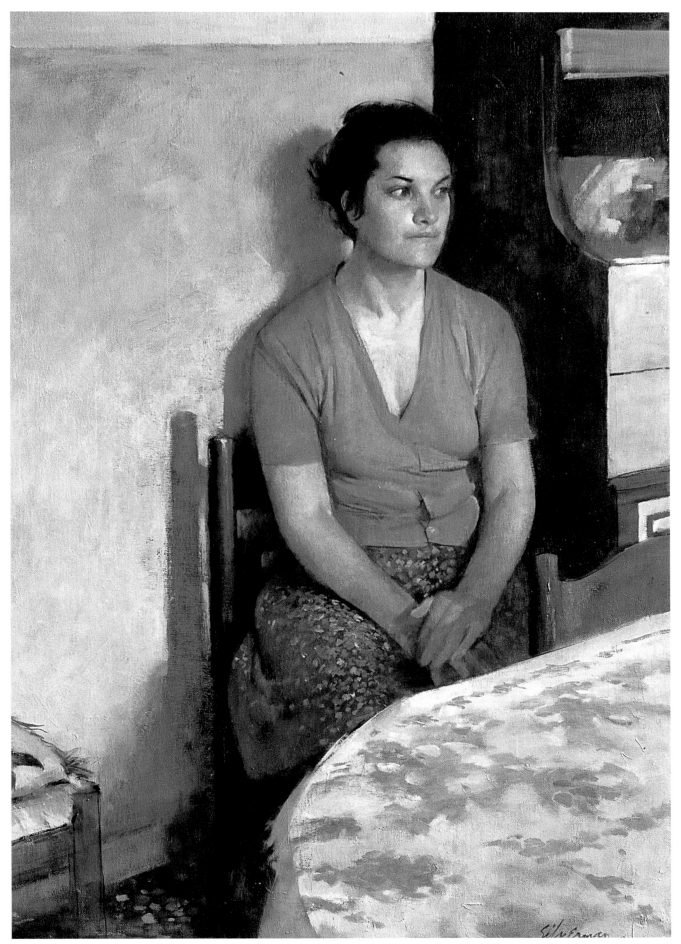

Plate 75. **Corner of the Kitchen**, 1981. Oil on linen, 32 x 24 inches. Collection of Anne and Charles Collins.

The neighborhood near my New York studio and home is rich in diversity, with women's wear boutiques, restaurants, flower mini-markets, and the full run of stores that service an urban community. Some of these have provided the subject matter for a lot of recent work. I was often fascinated by the mannequins in the women's dress and lingerie shops for a particular reason. The plastic mannequins were so slick and unchanging, with their blank looks and emaciated bodies, that I felt them to be a kind of strange sculpture, standing as sentinels to something really dangerous. I'm uncertain what that danger is; it's just a feeling. But I also noticed the women who stopped at the windows to look, not at the mannequins, but at the clothes. At that point an idea began to blossom, and it's still there: how the storefront is really a stage set against which all kinds of little dramas are played out. This painting was just the first of the images I intended with this theme. (See "On Women," Page 32.)

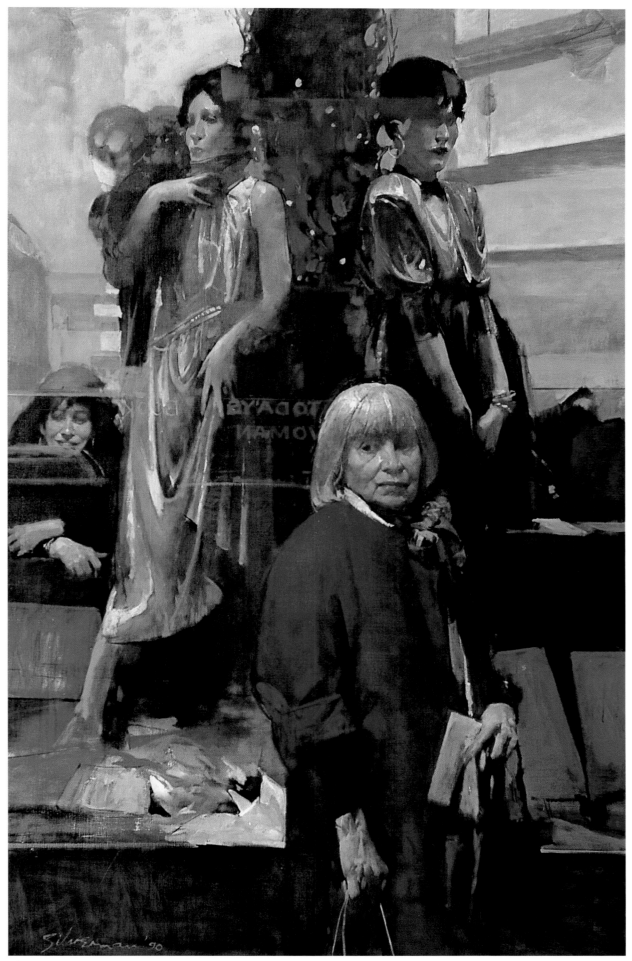

Plate 76. ***Christmas '88***, 1988. Oil on linen, 52 x 34 inches. Private collection.

Biography

Born: 1928, Brooklyn, NY • **Education:** BA, Columbia University • **Teaching Experience:** School of Visual Arts, NYC, 1964-1966 • Studio Classes, 1971-to present • **Positions:** Member of the Council; the National Academy of Design, 1976-1978 • Member of the Council; American Watercolor Society, 1992-1994

Awards & Honors

1997 Paul and Margaret Berkelson Prize, National Academy of Design (NAD), NYC

 Mario Cooper Award, The American Watercolor Society Annual (AWS), NYC

1996 Clara Stroud Memorial, The AWS Annual, NYC

1995 The Silver Medal of Honor, AWS Annual, NYC

1994 Clara Stroud Memorial, AWS Annual, NYC

1992 The Joseph Isidor Medal, NAD Annual, NYC

1991 The High Winds Medal, AWS Annual, NYC

 Smith Distinguished Visiting Professor, George Washington University, Washington, DC

 Elected Hall of Fame, Pastel Society of America

1990 Elected Hall of Fame, Society of Illustrators Museum of American Illustration, NYC

 The Catherine Stroud Memorial Award, AWS Annual, NYC

1989 The Mary Pleisner Memorial Award, AWS Annual, NYC

1987 The Mary Pleisner Memorial Award, AWS Annual, NYC

1985 The High Winds Medal, AWS Annual, NYC

1984 The Silver Medal, AWS Annual, NYC

1983 Henry W. Ranger Puchase Prize, NAD, NYC

1982 Painting Prize, Hudson River Annual, Hudson River Museum, Yonkers, NY

 Purchase Prize, American Drawings IV, Portsmouth Museums, Portsmouth, VA.

 Honorable Mention, Butler Institute of American Art, Youngstown, OH

 The Hardy Gramatky Memorial Award, AWS Annual, NYC

1981 The Paul B. Remmey Memorial Award, AWS Annual, NYC

1980 The Barse Miller Memorial Award, AWS Annual, NYC

1979 Elected member American Watercolor Society

 Purchase Prize, American Drawings II, Portsmouth Museums, Portsmouth, VA

 Gold Medal of Honor, AWS Annual, NYC

1977 Figure Prize, Pastel Society of America Annual, NYC

1972 Elected Full Academician, The National Academy of Design

1969 Elected Associate member, National Academy of Design, NYC

 First Benjamin Altman Figure Prize, NAD Annual, NYC

1967 Joseph Isidor Gold Medal, NAD Annual, NYC

1966 Thomas R. Proctor Prize, NAD Annual, NYC

1965 Henry W. Ranger Purchase Prize, NAD Annual, NYC

1964 Purchase Prize, Art On Paper, University of North Carolina

1961 S.J. Wallace Truman Prize, NAD Annual, NYC

Public Collections

The Anchorage Museum of Art and History, Anchorage, AK
The Brooklyn Museum, Brooklyn, NY
The Butler Institute of American Art, Youngstown, OH
Cornell University, Ithaca, NY
The Delaware Art Museum, Wilmington, DE
The Dillard Collection, University of North Carolina
Hofstra Museum, Hempstead, NY
The Mint Museum, Charlotte, NC
The National Museum of American Art, Smithsonian Institution, Washington, DC
The National Portrait Gallery, Smithsonian Museums, Washington, DC
The New Britain Museum of American Art, New Britain, CT
The Parrish Museum of Art, Southampton, NY
The Philadelphia Museum of Art, Philadelphia, PA
The Portsmouth Museum, Portsmouth, VA
The Queensboro Community College Art Gallery, NY
The Rutgers University Museum, Camden, NJ
University of Utah

Solo Exhibitions

1999 Retrospective: "Odyssey," The Butler Institute of American Art, Youngstown, OH
and The Brigham Young Museum, Provo, UT
1998 The Merrill Gallery, Denver, CO
1997 Gerold Wunderlich & Co., NYC
1996 The Merrill Gallery, Denver, CO
Gerold Wunderlich & Co, NYC
1993 Joseph Keiffer Gallery, NYC
1991 Capricorn Galleries, Bethesda, MD
1990 Cudahy's Gallery, NYC
1988 Grand Central Galleries, NYC
1983 Sindin Galleries, NYC
1980 Doll & Richards Gallery, Boston, MA
1979 Capricorn Galleries, Bethesda, MD
1977 FAR Galleries, NYC
Meredith Long Galleries, Houston, TX
1974 Harbor Gallery, LI, NY
1971 Harbor Gallery, LI, NY
1970 Kenmore Galleries, Philadelphia, PA
Gallery 52, South Orange, NJ
FAR Galleries, NYC

1967	University of Utah
1965	Kenmore Galleries, Philadelphia, PA
	FAR Galleries, NYC
1963	Kenmore Galleries, Philadelphia, PA
1962	Davis Galleries, NYC
1958	Davis Galleries, NYC
1956	Davis Galleries, NYC

Selected Group Exhibitions

1997 *Realism in 20th Century American Painting*, The Ogunquit Museum, Ogunquit, ME

1997-59 National Academy of Design, Annual Exhibition, NYC

1997-79 American Watercolor Society, Annual Exhibition, NYC

1994 *The Face of America:* Watercolors by 50 Contemporary Artists, Old Forge, NY

1994 *Getting Real;* Contemporary Realism from the Collection of Philip Desind; The South Bend Regional Museum, South Bend, IN

1991-93 *International Waters*, Travelling Exhibition in Canada, UK and USA

1993 Annual Exhibition, The Butler Institute of American Art, Youngstown, OH (Also for the years 1972, '76, '77, '79, '82, '88)
The Self; Self-portraits from the James Goode Collection, The National Portrait Gallery, Smithsonian Museums, Washington, DC

1990 AWS International Exhibit, The Mexico City Museum of Art

1987 *Mainstream America;* The Collection of Philip Desind, The Butler Institute of American Art, Youngstown, OH

1983 The National Drawing Invitational, Kansas State University

1982 The Hudson River Annual, The Hudson River Museum, Yonkers NY
American Drawings I, II, III, IV, Portsmouth Museum, Portsmouth, VA

1980 *20th Century Prints*, The Parrish Museum of Art, Southampton, NY

1978 The Childe Hassam Fund Invitational, American Institute of Arts & Letters, NYC (Also for the years 1976, 1974)

1975 *The Figure*, Penn State University Museum, PA

1973 Travelling Exhibition, Pratt Institute Graphic Center, NYC

1968 *The Collection of Walter & Lucille Fillin*, Hofstra University Museum, Hempstead, NY

1964 *Four Realists*, The New Britain Museum of American Art, New Britain, CT

1963 *75 Years of American Realism*, Hirschl & Adler Galleries, NYC

1962 *Contemporary American Realistic Painting*, Albany Institute of Art & History, NY

1961 *Contemporary Realists II*, Huntington Hartford Museum, NYC
A Realist View, The National Arts Club, NYC

1957 *The Artist As Reporter;* Drawings of the Montgomery Bus Boycott, with Harvey Dinnerstein, Davis Galleries, NYC

1949 The Annual of the Pennsylvania Academy of Fine Art, Philadelphia, PA

Selected Bibliography

Bossert, Jill

Hall of Fame 1990, Burt Silverman, *The Society of Illustrators 32nd Annual*

Carson, Claybourne

"The Boycott that Changed Dr. King's Life," *The New York Times,* January 1996

Case, Elizabeth

"Drawing the Human Figure; An Interview with Burt Silverman" *American Artist,* June 1972

Heller, Steven

Review, *ARTS* magazine, January 1985

Shawn, William

Catalogue Introduction, "Drawings from *The New Yorker*," Grand Central Galleries, 1988

Silverman, Burton

"Homage to Thomas Eakins," *Book World, Herald Tribune,* June 1968

"Art for Pablo Picasso's Sake," *Book World, Herald Tribune,* December 1967

"Painting People," Watson Guptill, NY, 1977

"Breaking the Rules of Watercolor," Watson Guptill, NY, 1983

"Rediscovering Realism," *US Art,* July 1990

"What Makes Art Great," *American Arts Quarterly,* July 1991

Silverman, Burton, with Harvey Dinnerstein

"A New Look at Protest: The Eight Since 1908," *ARTnews,* February 1958

"Drawings of the Montgomery Bus Boycott, *Esquire* magazine, December 1964

van Gelder, Pat

"Burt Silverman Captures the Moment," *American Artist,* June 1972

Whitaker, Frank

"Four Realists," *American Artist,* October 1964

MR. SILVERMAN has had a simultaneous career in illustration where, from 1959 until 1992, his work was commissioned by major magazines and corporations. These have included *The New Yorker, New York, Newsweek, Psychology Today, Time, Fortune, Life, Sports Illustrated, McCall's, Redbook, National Geographic* and *Esquire.* He has also illustrated children's books, record album dust covers, and ads for the print media. *The New Yorker's* feature, "Profiles," used Silverman's portrait drawings [done mostly from life] for more than thirty years. His advertising and institutional clients have included Exxon, Mobil Corp., CBS, Time Inc., Texaco, ABC, Heinz Corp., The Metropolitan Opera, Simpson Papers, IBM, AT&T and GE.

His paintings have appeared on the covers of *Time, Newsweek* and *New York* magazines from 1976 through 1990. He has also designed a dozen postage stamps for the US Postal Service including the Raoul Wallenberg Commemorative. He was awarded the One Show Gold Award of the Art Directors Club of N.Y. and has been included in features of *Print* and *Communication Arts* periodically from 1977 to 1998. His work has been shown in the Annual Exhibitions of the Society of Illustrators for almost 30 years, from 1964 through 1992. In 1990 the Society elected him to the Hall of Fame and in June of 1992 awarded him the Geismann Memorial Invitational Retrospective Exhibition. This show, held in the Society's Museum of American Illustration, included 120 pieces of Silverman's artwork spanning his thirty-three years in illustration. A collection of 90 of his drawings created for Bill Moyers' PBS series on the Constitutional Convention of 1787—*Report from Philadelphia*—was published by Random House in 1987.

Index of Illustrations